HIDDEN HISTORY
of
ACADIANA

William J. Thibodeaux

THE
History
PRESS

Published by The History Press
Charleston, SC
www.historypress.com

Copyright © 2019 by William J. Thibodeaux
All rights reserved

(On the back cover) Swamp scene at Lake Martin between Lafayette and Breaux Bridge, Louisiana. *Courtesy of Jack Winn.*

First published 2019

Manufactured in the United States

ISBN 9781467143578

Library of Congress Control Number: 2019937038

Contents

ACKNOWLEDGEMENTS

I am especially grateful to my wife, Judy, for her invaluable support and encouragement and for putting up with me spending countless hours researching, writing and compiling material for this work. She spent countless hours reading, editing and correcting spelling and grammatical errors.

Thanks go to The History Press, especially my commissioning editor, Joe Gartrell, who helped me tremendously along the way;

Jack Winn for his friendship and for his great cinematography skills;

J. Albert Guilbeau, my dear friend (now deceased), for all the wonderful stories and the Guilbeau family, especially Biker Bob, Simone and Brett Myhand of Carencro;

Barry Ancelet, professor emeritus of francophone studies and folklore at the University of Louisiana at Lafayette, for sharing local stories;

Allen LeBlanc of Abbeville for the many stories he has given me over the years;

Julie Simoneaux, library associate at Iberville Parish Library;

James Ackers of St. Martinville for his great memory and for sharing his stories;

The creators of the fantastic nonfiction book *The Slaughterhouse Cases: Regulation, Reconstruction, and the Fourteenth Amendment*, Ronald M. Labbé and Jonathan Lurie, for their exhaustive research—it is one of my favorite history books pertaining to early New Orleans;

Dr. David Edmonds for announcing the treasure trove of unpublished manuscripts locked away in the National Archives;

Dr. Eddie Palmer for information about early cattle trails mentioned in *The Slaughterhouse Cases*;

Professor C. Ray Brassieur for his talks on early cattle drives to New Orleans;

Professor Mike LeBlanc of Lafayette for his continued help with valuable information on photographs and mapmaking;

Alvin Bethard of Lafayette for finding hidden topics for me to research;

Joseph "J.C." Moreaux of Houston for his constant help with early railroads of Louisiana;

Ray Duplechain of Belle Chasse for his help with information on early railroads of Louisiana;

Bill Lamar of Morgan City for his continued help with railroads and photographs of old depots;

Burt Suir of Lafayette for sharing stories about the railroad;

Ann Mire of Crowley for her excellent help obtaining photographs of Acadia Parish;

Jean Vidrine of Ville Platte for her continued help on material at Dupré Library;

Bob Broussard, historian from Centerville, for constantly finding historical material to share;

Russell Landry of Kaplan for his valuable insight on salt mines and for sharing personal information;

Beverly Gisclair of Kaplan for sharing her personal story about the Belle Isle salt mine disaster;

Brenda Daigle for sharing her stories of her father, the late Pierre Varmon Daigle, and his many accomplishments in Cajun culture, especially his writing about Cajun music;

The late Carlos Daigle, son of Varmon Daigle, for valuable information concerning his father;

The late Selise Daigle of Pointe Noir for sharing stories about Pointe Noir and local musicians;

Pat Daigle of Church Point for sharing stories about Pointe Noir, Doris Matte and various musicians;

Paul Daigle of Pointe Noir for sharing stories of Cajun music and musicians of long ago;

Kelly Hebert of Church Point for sharing stories of his mother and father, Adam Hebert and other musicians;

Whitney Sonnier of Pointe Noir for sharing stories of Cajun music, musicians and dancers;

Gercie Daigle of Church Point for sharing information on Auguste and Octave Thibodeaux and other related stories;

Viola Fontenot of Lafayette for sharing her stories of the Great Depression and of Cajun culture;

The late Albert Guilbeau, again, for sharing stories about the shootout at the Lafayette railyard;

Helen Gaspard Hayes of Gueydan for sharing photographs and stories of Vermilion Parish;

Jerry Clark of Morse for sharing stories of Acadia Parish;

Wiley "Butch" Clark of Kaplan for sharing stories of Cajun culture;

Rogers Romero of New Iberia for his friendship, continued support and photographs of New Iberia;

Jack Patin of Lafayette for his personal stories about his father and his grandfather, who worked for the Southern Pacific railroad;

Warren Perrin for his continued support and sharing stories of Charles Frederick from Erath;

The Council for the Development of French in Louisiana (CODOFIL) and Louisiana Public Broadcasting (LPB) for interviewing Ralph LeBlanc entirely in French in 1987;

Albert "Buzz" LeBlanc of Breaux Bridge for sharing stories, newspaper articles and photographs of Operation High Jump;

Eric Castille for sharing interesting tidbits of historical info, stories and great books as well as good conversations;

Deen Thomas for his generous offer of historical photographs;

Bevan Bros. Photography of Eunice for its generous offer of historical photographs;

Acadia Parish Library and its wonderful staff, also the tireless genealogy workers;

Lafayette Parish clerk of court Louis J. Perret and his gracious office staff;

Pat Hebert of Branch for valuable knowledge pertaining to local history;

Francois Comeaux of Maurice for sharing stories of Vermilion Parish;

Richard Landry of Maurice for sharing stories of Vermilion Parish;

Louis Broussard of Milton for sharing stories of his grandfather and the Wild West;

Herman Venable of Lafayette for his many stories pertaining to the Great Depression and Pointe Noir;

Franklin and Norma Price for sharing stories of trapping, fishing and shrimping;

Ms. Louella, Maurice librarian, for the gracious help;

And last but certainly not least, my friend Ms. Pat Segura of Abbeville for encouraging me to write a book. Well, here it is.

INTRODUCTION

*H*idden History of Acadiana is a collection of fascinating short stories that chronicles south Louisiana's enormous and diverse history and heritage. We are "keeping local history alive in sepia tones," to borrow from Ron Charles, a great writer for the *Washington Post*. All the following stories are nonfiction, and they are about people, places and events of long ago. Some date back to the antebellum period, but most take place during the late 1800s and early 1900s, like "Sketch of Vermilion Parish." In the early 1900s, a notable historian wrote a series of sketches about the parish. He described in detail the near perfectly circular ponds that were "thickly interspersed" in an unspecified order and were found only in Vermilion and Iberia Parishes. These ponds ranged in size from 50 to 150 feet in diameter and were perhaps no more than 12 to 24 inches deep. A team of leading scientists during that era determined that the ponds weren't the work of indigenous people. The question begs to be asked, if the ponds were not man-made, then what created them?

THE DARK HORSE

This is the story of an old white Thoroughbred with a funny name—Twenty-Twoinit. The horse belonged to the late J. Albert Guilbeau of Lafayette, originally from Carencro. Many horseracing fans of the 1960s and 1970s from south Louisiana remember the old gelding at Evangeline Downs Race Track before the track moved. Albert Guilbeau purchased the racehorse from a California horse dealer who was driving through the area on his way to Florida. The old horse had a swollen foreleg. Albert's trainer, Adam "P.D." Suire of Erath, knew a lot about horses. He was sure the horse's leg would heal, and he knew Guilbeau was shopping for a horse for his youngest daughter, Cecile, who usually followed her father to watch the horses. P.D. informed Albert about the California horse dealer who had just stopped by the stable with several horses, including the white Thoroughbred with a hurt foreleg. Albert thought P.D. was crazy for recommending a racehorse for his ten-year-old. P.D. calmed Albert down and had Albert at least look at the horse. This wasn't your average high-strung racehorse. This horse was calm and seemed to notice everything going on. P.D. knew this would make an ideal horse for any child. After a few minutes, Albert bought the old horse for Cecile for her tenth birthday. Albert knew if he didn't buy Twenty-Twoinit, the horse was probably headed to the soap factory.

Residents in Oaklawn Park subdivision remember seeing the old white gelding calmly riding the neighborhood children bareback down the residential streets—sometimes as many as three or four at a time. Albert's

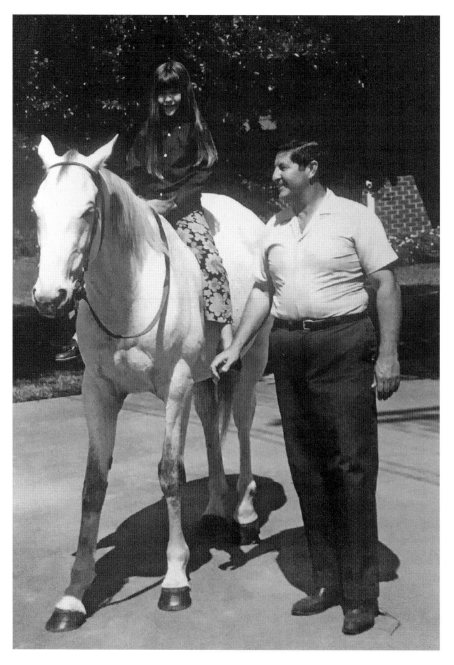

J. Albert Guilbeau and daughter Cecile on Twenty-Twoinit. *Courtesy of the J. Albert Guilbeau family.*

wife, Eva Delle, said, "The horse seemed to enjoy all the attention given to him by the kids." Twenty-Twoinit was kept in a vacant sweet potato field near the old Evangeline Downs along Interstate 49 at Carencro, where sounds of excitement could be heard coming from the racetrack. When Twenty-Twoinit heard the crowd and the sound of the starting gate's bell, he would bolt and run around the pasture at top speed as if he was participating in the race. Lots of folks driving along the highway remember seeing the riderless horse running at breakneck speed. P.D. was right—it didn't take long for Twenty-Twoinit's leg to heal. After some persuading, P.D. began to work with the horse to get him in running condition. The trainer loved that old horse and thought the horse wanted to run. He decided he'd help him. But after the horse was looking fit, P.D. had second thoughts. He didn't want to see the aging horse get hurt. He told Albert that the horse was intelligent and had an excellent temperament and a big heart but was too old to race. Albert insisted the horse wanted to run.

They consulted Lane P. Suire, P.D. Suire's son, who rode Twenty-Twoinit and said, "He really pushed the bit, he wants to go!" Albert wanted to see how the horse with the funny name did on the racetrack. The old gelding not only raced, he also won a number of races with notable jockeys from Acadiana, including Lane Suire, who later became one of the top jockeys in the country. One of the most exciting times was when an expensive and beautiful horse from New Orleans named Brilliant Dunce arrived at Evangeline Downs. P.D. Suire begged Albert not to run the old horse. "Brilliant Dunce is young and he's huge. He will run circles around old Twenty-Twoinit," said P.D. Albert wouldn't hear it. The date of the big race arrived—June 27, 1968. It was billed as the feature race at Evangeline Downs—the Crepe Myrtle Purse.

It was a stressful time for P.D. He was afraid for the old gelding. He didn't want to see him hurt again. The race was six and a half furlongs, slightly less than a mile. Was that considered too much for horses? Secretariat, the Triple Crown winner in 1973, was an amazing animal blessed with a combination of speed and stamina. The Triple Crown is composed of three races: the Kentucky Derby, which is one and a quarter mile; the Preakness, which is one and three-sixteenths of a mile; and the Belmont Stakes, which is one and a half miles. Winning all three races is a huge accomplishment indeed—and a very rare achievement. It takes endurance.

In the mid-1800s, it wasn't uncommon to see horses run a four-mile race and often more than once in a day. One of those Thoroughbreds that ran a four-mile race in the mid-1800s hailed from Louisiana. He was a rich

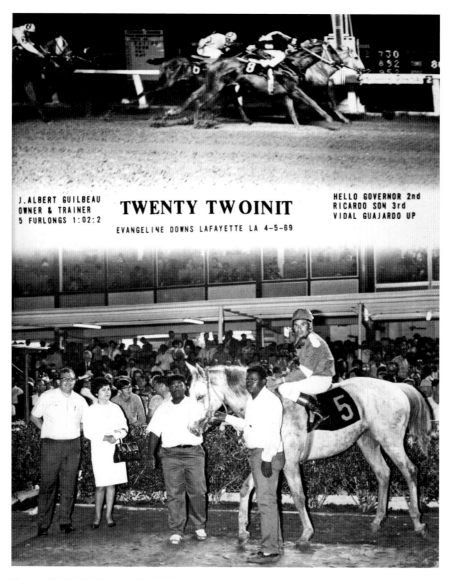

On April 5, 1969, Twenty-Twoinit is the photo finish winner by a head at Evangeline Downs. *Courtesy of the J. Albert Guilbeau family, Frenchie Thibodeaux and Evangeline Downs Racetrack.*

chestnut brown with one white-stockinged hind leg. The owner was Thomas D. Wells, who owned a plantation south of Alexandria. Many horseracing fans considered his Red River colt to be the fastest in the world. The magnificent racehorse frequently won races at the New Orleans Fairgrounds. His maiden victory was in 1853 at the Metairie Race Course, as it was called back then. A year later, on April 8, 1854, it was widely known that the two best horses in the country would compete in New Orleans. The other horse was a bay from Kentucky. Both horses were in exceptional racing condition, and it was said that the two had excellent temperaments, easily placed in a race and responded well. They had strides of 23 feet and would pull away from the rest of the pack like quarter horses. The Thoroughbreds each stood 15.3 hands high (63 inches) at the withers.

The racetrack was packed to capacity with people from nearly every state in the union, reported the *New Orleans Democrat*. It was said that no one was holding back on bets. The Red River colt ran a record-breaking time of seven minutes and twenty-six seconds. More importantly, the colt had just handed the champion horse from Kentucky his first career defeat. This would be remembered as the greatest four-mile race on record. The two horses were actually brothers; they were both sired by the world-renowned white-face stallion named Boston, and the Kentucky bay was the world-famous Lexington. The Red River colt was named Lecomte, and later a small town in central Louisiana was named after him. In 1856, Richard Ten Broech, the owner of the Kentucky champion, purchased the Red River colt for $10,000. Lecomte was sent to England, where he later died of colic, a digestive ailment. Each year, the New Orleans Fairgrounds has a one-mile, $100,000 race in honor of the Red River colt named the Lecomte Stakes. During the days of Lecompte High School, the yearbook was named the *Lecomte* and had a picture of the Thoroughbred on the cover. When the railroad painted the station sign on the depot, a *p* was accidently added to the town's name, and it has been Lecompte ever since.

I digressed a bit to tell you about Lecomte. Now back to the old Evangeline Downs and the big race. The date was June 27, 1968, and the race was set. When the starting bell sounded and the door swung open, Twenty-Twoinit shot out of the gate like a cannonball! Brilliant Dunce sprang out of the gate too and followed closely behind. Twenty-Twoinit stayed in the lead the entire race and crossed the finish line several lengths ahead of the others. P.D. shouted, "Wow! What a gift from heaven!" Twenty-Twoinit won the six and a half furlongs with a time of one minute and twenty seconds. Twenty-Twoinit not only won the race, he also badly burned the Vegas oddsmakers.

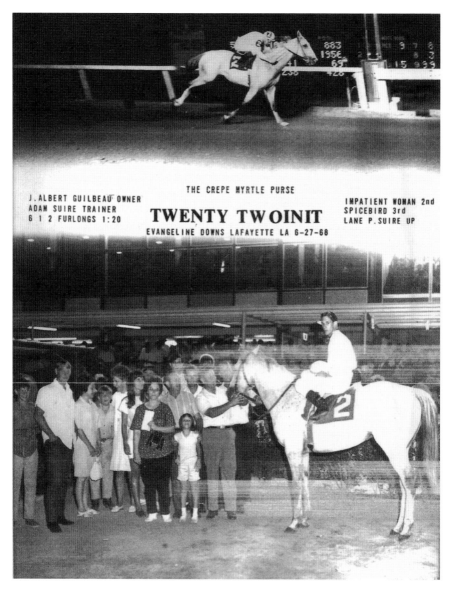

On June 27, 1968, Twenty-Twoinit wins the Crepe Myrtle Purse in a photo finish. Twenty-Twoinit is pictured with the Albert Guilbeau family. *Courtesy of the J. Albert Guilbeau family, Frenchie Thibodeaux and Evangeline Downs Racetrack.*

The old horse won numerous races between 1967 and 1975, but he began to show signs of aging. It became harder and harder for him to complete the races. Albert agreed with P.D. that it was time to semi-retire the horse. The old gelding was held in high esteem and was used as a pony horse, a chore normally reserved for quarter horses. Twenty-Twoinit would bring young Thoroughbreds from the stables to the starting gates. Albert said the old horse seemed to enjoy his role as a pony horse. Unfortunately, sometime later, Twenty-Twoinit was kicked by one of the Thoroughbreds, shattering his once-injured foreleg, and he had to be put down.

The news was devastating to the Guilbeau family, especially to Cecile and P.D. Suire. Albert said there was not a dry eye at the racetrack when the old gelding was put down. He said, "P.D. cried like a baby, he really loved that horse." Many times, P.D. was heard saying how Twenty-Twoinit's earnings paid for his house. After that event, Albert lost all interest in horseracing. He sold everything and got out of the business of racing and of raising horses. A number of years later, Albert and friends took a trip to Las Vegas. While there, they visited one of the betting parlors. Albert said he'd like to place a bet on some Evangeline Downs races. The attendant glared at Albert and said, "Mister, we don't take bets for Evangeline Downs!" Before Albert could ask why, the attendant said, "Not since an old white, broken down horse with a funny name took us to the cleaners!" Albert knew he was talking about Twenty-Twoinit. Truth be told, when the horses were at the starting gate, the jockey riding Brilliant Dunce fell off his mount and was immediately disqualified.

Sketch of Vermilion Parish

On October 28, 1905, Wakeman W. Edwards, a prominent attorney and judge from Abbeville, began writing a series of articles identified as historical sketches of Vermilion Parish. They were published in the *Meridional* of Abbeville and have been used extensively by historians over the years. In his historical sketches, Wakeman Edwards wrote in detail about what he described as nearly perfect circular ponds that were "thickly interspersed" or scattered about in no certain order in Vermilion and Iberia Parishes. The ponds ranged widely in size from 50 to 150 feet in diameter and were perhaps only 12 to 24 inches deep. They were all nearly perfect circles, not oval, oblong or any other shape. What were these strange circular ponds on the windswept prairies? More importantly, how were they created? Wakeman Edwards had determined that they weren't natural formations, nor were they the work of Indians. Then who or what created the circular ponds? Could they have been created by meteor showers thousands of years ago or by some extraterrestrial entity? Were they perhaps some form like crop circles? As you can probably imagine, it was the source of much speculation over the years. It was as if someone—or some celestial being—had visited the area and created the mysterious circular ponds, but why?

The ponds were mostly full of water due to rainfall over the years, and the cattle that freely roamed the prairies during that period frequented the ponds, especially during the dog days of summer. Cattle stood in the ponds to drink and cool off, and at night, the ponds were great resorts for the

multitude of ducks, especially during the fall and winter. Early settlers of the area grew fine crops of rice in and around the ponds with little or no difficulty. Wakeman Edwards wrote that the plow had obliterated nearly all the circular ponds, and he feared that within a short timespan they would all disappear.

One possibility for the ponds' origin is that they were created years ago when buffalo roamed the area in huge herds—before they were nearly all decimated. The buffalo clustered together to avoid flies and mosquitoes, frequently stamping their hooves to shake off the pests. The stamping created holes in the soft marsh. Water collected in the mudholes, and mud collected on the buffalo. When they left the ponds, the mud shook off, and when they returned, the process repeated itself. Over time, the mudholes deepened, creating small ponds. But how did the buffalo create so many perfect circles, which were said to be nearly alike? It's truly a mysterious phenomenon.

These circular ponds extended westward to Coulee Michel near Gueydan, where they abruptly stopped. Although no circular ponds existed west of the coulee, another new and equally mysterious phenomenon began at that exact location. Or, as Wakeman Edwards wrote, where the round ponds cease, the round mounds begin. These weren't Indian mounds; some have speculated that they may have been created by insects like ants. The mounds were large: from six to fifty feet in diameter and anywhere from eighteen to thirty inches in height, some possibly a little higher. The mounds were flat, circular and extended from Coulee Michel west to Lake Arthur and into Calcasieu Parish. They were said to be composed of sand and clay. Wakeman Edwards reported they were not like the mounds of Arkansas, which he had personally examined.

Wakeman Edwards also wrote that a Professor Hilgard in his geological survey of Louisiana mentioned that he and other scientists had examined the formations without declaring their origin. No doubt Wakeman Edwards was referring to Dr. Eugene W. Hilgard, a noted German American expert on pedology—the study of soil resources. At the time, Hilgard was an authority on soil chemistry. He was considered the father of modern soil science in the United States and wrote a paper on his survey of Louisiana in 1869. Probably the most bizarre and mysterious aspect of the ponds and the mounds of the prairies is the fact that no ponds existed where mounds were found. The mounds and ponds remain an unsolved mystery. While researching this strange anomaly, I came across a small but very interesting narrative about how the community of Meaux came about. Sometime in the late 1800s, the community northwest of Abbeville was originally named

Harrington's Island. The Harrington family built their home on high ground surrounded by the small circular ponds.

Wakeman Edwards was the first resident of Vermilion Parish to ever hold the office of district attorney. He was appointed by then-governor Francis Nicholls after Judge Conrad Debaillon resigned. At the time of his sketches, Judge Edwards was greatly concerned with the void of missing Vermilion Parish history. First, the state capitol at Baton Rouge was burned during the War Between the States, and all the records it contained were destroyed. Next came the destruction of all the courthouse records in Vermilion Parish by fire on the night of April 6, 1885. At the time of Wakeman Edwards's writings—or sketches, as he referred to them—there were very few people left who had been in Vermilion Parish since 1844, when the parish was created. Not many people knew of the Attakapas District and of southwest Louisiana, nor did they know of its vast prairies. Up to that time, the history of thousands of men and women who had lived and died in Vermilion Parish was largely unknown. They were all simply neglected. Wakeman Edwards decided to take up the matter himself and preserve as much history as possible. He began by interviewing some of the more senior residents of the area, but unfortunately, remembering all the dates, names and events was a problem for many. Too much time had elapsed. Wakeman Edwards implored his readers to preserve history for posterity. Otherwise, the information might never appear in any other form.

According to Judge Edwards, Vermilion Parish was created in 1844 by Act Number 81. At the time of its creation, the area that is now Vermilion Parish was in what was then known as the county of Attakapas. Edwards fully describes the parish boundaries, which he admitted were imperfectly demarcated. Vermilion Parish was established during President John Tyler's administration. At the time, the country was just beginning to recover from its first great depression, known as the Panic of 1837. The judge reported that many businesses closed their doors and never opened again. The area that became Vermilion Parish was more than half of the territory of former Lafayette Parish. A large portion of that area included sea marsh along the Gulf of Mexico, which was considered worthless and uninhabitable. When Vermilion Parish was created, the parish seat was located at Perry's Bridge on the west bank of the Vermilion River. It was on land that belonged to Captain Robert Perry. Back then, Perry's Bridge was the trade center of the new parish. Perry also owned a drawbridge spanning the Vermilion. When a post office was established there, it was named Perry, as it remains today. On the bank of the bayou just below the end of the bridge was a place selected

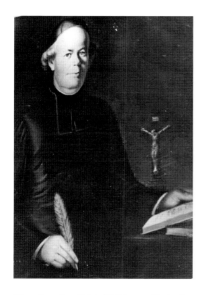

Père Antoine Désiré Mégret, Catholic priest at St. John's Cathedral in Lafayette, established La Chappelle (Abbeville) and St. Mary Magdalene Catholic Church of Abbeville. *Courtesy of Lafayette Parish clerk of court Louis J. Perret.*

for a courthouse, although according to Judge Edwards, it was quite small for a public square. On the main street, a lot was given for a Protestant church and another for a Catholic church. Father Antoine Désiré Mégret, or Père Mégret as the Cajuns called him, was from France and was appointed to the new parish of Vermilion. After inspecting the lot offered for the Catholic church, Père Mégret objected about the location for one reason or another. He asked Captain Perry for a more suitable lot, which Perry refused. The two men parted ways, and according to Wakeman Edwards, there has never been a Catholic church in Perry.

It's uncertain what actually happened between Père Mégret and Captain Perry. Perhaps the priest's reputation preceded him. Before arriving in Vermilion Parish, he was the parish priest just twenty miles upriver at St. John Catholic Church in Vermilionville. At the time, there was said to be a dispute between the Catholic Church and the church wardens of St. John. The disagreement had been going on for a while, and by the time Père Mégret got there, the situation had reached the breaking point. Père Mégret soon became frustrated with the entire state of affairs and decided to move downriver. He purchased forty arpents on the east bank of the Vermilion from Joseph LeBlanc for $400 of his own money. After the encounter with Captain Perry, Père Mégret decided to build a town too while he was at it; he had intentions of it being similar to the old towns of France with tiny crooked streets. The town was described as having 848 feet of waterfront on the Vermilion with a depth of 1,979 feet. A large area on the waterfront was laid out for the church, parsonage, cemetery and several lots for the church's use. This property, according to Judge Edwards, was donated by Père Mégret to the church. In the beginning, the area was known as La Chappelle, probably after a town in France. The town of Abbeville was drawn out sometime about 1847. It was presumably named after Abbeville on the Somme in France, which was where Père Mégret was from. Abbeville

St. John's Cathedral of Lafayette, where Père Antoine Désiré Mégret was first assigned as priest before moving downriver. *Courtesy of Lafayette Parish clerk of court Louis J. Perret.*

was incorporated on March 13, 1850. The town was governed by a mayor and four aldermen. It grew rapidly, since it was on a navigable waterway in the center of a vast prairie.

Abbeville quickly became a rival of Perry's Bridge. A struggle ensued for a number of years after the seat of justice was moved from Perry's Bridge to Abbeville. What made matters worse, wrote Judge Edwards, was the fact that since its charter, section six, where Père Mégret had his church, was exempted from parish taxes (the tax exemptions lasted at least until 1902, when Wakeman Edwards was writing his sketches). Vermilion Parish had been established for ten years and still had no courthouse to call its own. Perry's Bridge was dealt a fatal blow when the Louisiana legislature approved an act on March 31, 1854, that made Abbeville the permanent seat of justice for the parish. The sheriff published that fact and informed the police jury that the seat of justice and offices should be removed from Perry's Bridge posthaste for the purpose of a new courthouse, jail and other necessary office buildings being erected in Abbeville.

The early settlers must have thought that the vast prairies resembled an ocean with their gently swaying tall grasses. There were few groves of trees scattered about that probably looked like tiny islands. Wakeman Edwards was told by some of the first families to settle in the area that the prairie grass was thick and as tall as a man's head on horseback. People traveling overland back then did so in large homemade oxcarts called beef carts. According to the judge, they were made entirely of wood—no nails or iron were used in their construction. They were hand-hewn out of rough timber and held together by wooden pegs and mortises, sometimes aided with strips of rawhide. The wooden carts were heavy and strong, capable of carrying heavy loads for great distances over the smooth surface of the prairie. The axles were lubricated with tallow rendered from beef or mutton fat.

Edwards also named another cart known as an Attakapas carriage. This was a cart or gig like what the old deacons rode in, drawn by only one horse. It was made of light wood without any iron, like the beef carts. The seat was supported by rawhide straps and swung back and forth like a cradle. It was also called a *calleche*. According to Wakeman, the carts were used in Vermilion Parish up to and during the War Between the States. After the war, they began to disappear. Very few carts were seen after 1875. Wakeman reported that the late Madam Michel Hardy, one of the oldest residents of Vermilion Parish at that time, would ride to Abbeville in a calleche. Back then there were no roads, and anyone could travel in any direction across the vast prairies, which weren't fenced in. There were lots of cattle on the prairies

between 1844 and 1854 to keep down the grass, unlike in earlier times. And the prairies were burned each winter in order to have an early grazing in the spring. During the decade from 1844 to 1854, the principal settlements were along Bayous Vermilion, Tigre and Que de Tortue, with few settlers at Prairie Greig, Grand Chênière, Lake Arthur and Lake Peigneur. The main occupation for the majority of the inhabitants back then was raising cattle. Wakeman reported that the early inhabitants lived in small, dirt-floored, one- or two-room wooden houses with stick-and-mud chimneys. The windows were without windowpanes, and the space between the logs of the cabin was filled in with a mixture of mud and Spanish moss. There was always a cow pen or corral for keeping cattle, a corn crib and a small garden. They usually planted several acres of corn, which the women tended to. They also raised poultry, milked cows and spun and wove cottonade and other fabrics. The husbands rode about the prairie barefoot on their Attakapas ponies tending their herds of cattle and horses.

The population of Vermilion Parish in 1858 was 3,210 whites, 19 freemen and 1,370 slaves, which made a grand total of 4,599 souls in the parish. Also in 1858, Vermilion Parish had the dishonor of being one of the most illiterate parishes in the state of Louisiana. According to Wakeman Edwards, in 1858, there were twelve public school districts in Vermilion Parish, which were all white. There were no private schools in the parish. Reading, writing and French were taught. The report showed how many students attended school in each district, and each district was about the same regarding attendance. The first district reported 11 students who attended school and 75 who did not. The amount paid to teachers was $155.35. The eleventh district taught 4 pupils for three months at a cost of $231.00. In Wakeman Edwards's sketch of 1905 concerning Vermilion Parish, he indicated that the census report for 1900 showed it to still be the most illiterate parish in the state.

BLACK SUNDAY

One hundred sixty-two years ago, a violent storm demolished Isle Dernière or Last Island, a barrier island twenty miles off the coast of Terrebonne Parish in south Louisiana. In the mid-1800s, the island was a pleasure resort before it was destroyed by the 150-mile-per-hour winds of a hurricane beginning on August 10, 1856 (storms were not named until 1953). It was Louisiana's first great storm and one of its deadliest. It is ranked as the tenth strongest in U.S. history. Two hundred lives were lost on the resort island that summer. Scientists say the great hurricane probably developed in the southeastern Gulf of Mexico. Last Island is slightly ox-bowed, with the concave side facing the mainland. It is so named because it is the last or westernmost in a chain of small islands west of the Mississippi River. It was about twenty-five miles long and one mile wide, and its highest point was less than five feet above sea level. During the great storm of 1856, Last Island was split in two nearly equal halves. Over time, pounding winds and surf have reduced it to five smaller islands, known as Isles Dernières. It is now about eight miles long and approximately one-third of its former self.

The island was said to be a charming village of cottages facing the Gulf of Mexico. It was Louisiana's southernmost outpost of civilization, and it was a popular and fashionable summer resort. It was the most visited resort in Louisiana. Vacationers enjoyed white sandy beaches, clear water and an almost continuous southerly sea breeze. It was the ideal place for evading the suffocating heat of the mainland or for avoiding yellow fever. One-story cottages on the island were occupied almost entirely by some of the

wealthiest families in Louisiana along with their servants. That summer, a large portion of the wealthy male planters stayed home to attend to their plantations, while many women, children and servants perished in the storm. The island reportedly stayed submerged for several days after the storm before parts of it re-emerged. The only things that remained were the foundations of some of the sturdier homes and cisterns that were made of brick.

The largest structure on the island was a hotel that included a restaurant and ballroom and offered bowling and billiards. There were also several gambling establishments. Music was furnished by an old German fiddler. Several hundred yards west of the hotel was the settlement known as Last Island Village, which consisted of approximately one hundred beach homes; some were fine houses, and others were summer homes. There were probably a few people who lived year-round on the island. Regular steamer service to the island was provided by the *Star* from Bayou Boeuf. The New Orleans, Opelousas & Great Western Railroad (NOO&GW) provided a connection to Bayou Boeuf from Algiers, Louisiana, which was just a short ferry ride across the Mississippi River from the French Quarter landing at St. Ann Street. Regular railroad fare was $3.50 with half-fare for children and servants.

As early as 1847, pleasure trips were being made to Isle Dernière. By 1852, it was reported that several hundred families were spending their summers there. In 1854, the hotel was built, and more than thirty private residences were occupied that summer. The island had a beautiful beach twenty-one miles in length. A massive two-story construction of timber contained many apartments. Behind the hotel was the village bayou, where passengers boarded the steamships. The *Star* made twice-daily trips, and the *Major Aubrey* made weekly trips to Last Island from Plaquemine in Iberville Parish. There were other steamships from New Orleans, Franklin and other areas too.

One of the survivors of the 1856 hurricane was Emma Mille from the town of Plaquemine. In 1935, on her ninety-eighth birthday, which was almost eighty years after the great storm, Emma Mille gave an interview to the *Times Picayune* about the calamity of Last Island. In 2004, Anthony P. Fama shared the story in *Plaquemine: A Long, Long Time Ago*. At the time of the great storm, Emma Mille was a young woman of nineteen. She and her family—father Pierre Thomas Mille, mother Marie-Pauline Dupuy Mille, brother Homer Mille, his wife and their baby all boarded the *Major Aubrey* at Plaquemine and steamed to Last Island.

Emma remembered the weather was very warm that August, and everyone raved about the beautiful oleanders and the magnificent oak trees on the island. She also vividly remembered how the great hotel was packed with vacationers. Emma explained how her father owned a home on Last Island for several years but, for whatever reason, had never used it until the summer of 1856. She also remembered that Saturday, the day before the storm of 1856, how the wind began to blow very hard and the waves were pounding the beach. The steamer *Star* did not arrive Saturday evening as scheduled.

The next day was August 10, 1856, which she always afterward called Black Sunday. It began as a hot day with a light rain falling. As the day progressed, the wind began to work up in strength. Emma's father was nervous and asked one of the local men who spent most of his time on the island what he thought of the weather. The man replied, "There is no need to worry. We have had storms here before." Emma and her family were scheduled to return home on this day. By late afternoon, everyone was looking for the steamboat. The *Star*, with Captain Abraham Smith, was scheduled to make regular trips to Last Island twice each day—once in the morning and once in the afternoon. People were nervous; some went to the beach to look for the steamer. About mid-morning on Sunday, the *Star* arrived amid hurricane-force winds. The great storm was making landfall, and the frightened vacationers couldn't believe their eyes when they saw the *Star*. It was tossed about on the sands in front of the big hotel. Although Captain Smith had the crew drop as many as three anchors to hold the steamship, the *Star* was unable to dock and ran aground. The captain then ordered his crew to remove the wooden cabins, leaving only the hull of the ship intact, which enabled it to remain anchored instead of being dragged across the island by the wind.

Many of the vacationers had taken shelter in the hotel, because it was a solidly built two-story structure. Emma and her family didn't go to the hotel, because her sister-in-law was worried over her sick child. Sometime between 4:30 and 5:00 in the afternoon, she and other members of her family felt the house shake. The entire family and servants had been gathered in one room. Suddenly, Emma heard a crash and found herself in midair. A piece of lumber had fallen on her head, and blood was gushing for the cut. Amazingly, she remained conscious. The next thing she knew, she was being carried out to sea. A piece of lumber floated by, and Emma managed to latch onto it. Emma's sister-in-law and her baby were washed under a wave. A tidal surge between eleven and twelve feet completely submerged the island, destroying every structure on Last Island. Emma drifted all night. Logs and other debris

struck her at times all throughout the night. Sometime during the morning, she washed up on the beach at Last Island. Her white muslin dress was torn to shreds, and her head had a bad cut. She was exhausted lying there on the beach.

At some point, a black man who was one of her father's body servants came along. He informed Emma that her brother, father, sister-in-law, mother and the baby had all been lost. The man carried her to where others had gathered and then to the wrecked *Star*. Someone went for a young doctor who had also been washed out to sea and later beached just like Emma. Emma said that he was Dr. Alfred Duperier of New Iberia. He was staying at the large hotel like many of the young men vacationing on the resort island. During the storm, young Dr. Duperier rushed from the hotel to a nearby cottage and tied himself to a very heavy armoire, which is what he was riding on when he was washed into the Gulf and later returned to the beach. He was very weak but managed to walk back to the wrecked hotel and the steamship *Star*. Then someone brought him to Emma to take care of her injuries. Dr. Duperier learned that Emma's parents had been lost and now she was an orphan. At that time, Emma was too weak and bruised to walk. The doctor told Emma that his mother lived in New Iberia (in a home that later became Dauterive Hospital), and Emma was more than welcome to stay there with her, which she did. Emma said how nice and kind Dr. Duperier's mother was. "My own could not have been kinder."

It was a sad homecoming for the survivors. They all had family members who died on the island or were lost in the gulf. Emma was greatly affected by the ordeal for a long time afterward. It also took a long time for the wound on her head to heal. Emma's uncle from Plaquemine learned that she was the only member of her family who survived the storm. Emma's brother-in-law went to New Iberia to take her back to her parents' plantation near Plaquemine. The only immediate family members Emma had left were her two sisters: Mrs. Odillion Labauve and Emma's younger sister, Eugenia Mille, who was at a convent while the family vacationed on Last Island. When Emma left New Iberia for Plaquemine, Dr. Duperier gave her a small book of religious poems. When she got home, she found a note that had been tucked inside. After nearly eighty years, Emma was able to recite every line verbatim. Dr. Duperier wrote: "As Divine Providence saved us miraculously, it must be that we are destined for each other." Two weeks after Emma had returned home, the good doctor went to Plaquemine to see her. He said that he could never forget her and that he wanted to marry her. Dr. Duperier proposed right then. Emma recalled, "And what could I do but accept?" The

two were married on December 8, 1856, scarcely four months since they met. After their wedding, the couple lived in New Iberia, where the young doctor was well known and well respected. His family were founders of the town. From this union, five children were born. At least two became medical doctors, and one became an attorney.

Dr. Alfred J. Duperier died at 8:30 on Wednesday morning, March 23, 1904, from pneumonia that had complicated his already weakened heart. He was seventy-nine years of age and survived by his wife, the former Zoe Emma Mille of Plaquemine, and their five children. Dr. Duperier was buried in New Iberia. Emma spent the rest of her life in New Iberia, "happy years of raising a family and watching my grandchildren and great grandchildren grow up." In 1935, the house where she and the doctor first lived became a convent. While living there, Emma etched her name on a window pane with her engagement ring. Also, in 1935, while looking back at Black Sunday of August 10, 1856, she had many questions that came to mind. Could this tremendous loss of life and property have been prevented? Why didn't the people on the island leave prior to the approaching storm?

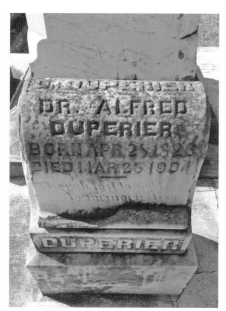 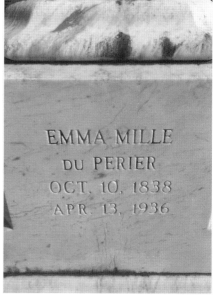

Left: The tomb of Dr. Alfred Duperier (1826–1904). He and his father, Frederick, fought to create Iberia Parish. *Photograph by William Thibodeaux.*

Right: Tomb of Emma Mille Duperier (1838–1936) of Plaquemine, survivor of Isle Dernière storm and wife of Dr. Alfred Duperier. *Photograph by William Thibodeaux.*

Back in 1856, there was no electricity, radios or weather broadcasting. The only information they received was from the steamers arriving from the mainland. Even if they had wanted to leave, there were no boats to take them off the island. Emma also wondered why the steamer *Star* continued toward Last Island instead of turning away from the approaching storm. She said, "It is almost certain that had the *Star* turned away, all of the 400 people on the island would have died. But because of the heroic bravery of Captain Smith and his crew more than half of the people on the island survived." Zoe Emma Mille Duperier died on April 13, 1936, and is buried at St. Peter's Cemetery in New Iberia. One thing that might have consoled Emma is knowing that if the great storm of 1856 had struck one year later, there would have been far more deaths and property damage. In 1856, the St. Charles Hotel of New Orleans proposed building the Trade Winds Hotel on Last Island the following year. Plans for the hotel had been drawn, but once news of the great storm was made known, it was immediately scraped. Today, it is said that Last Island's only inhabitants are a few stunted and gnarled dead and darkened oak trees protruding above the water, resembling blackened skeletons.

EVANGELINE

Henry Wadsworth Longfellow's fictional *Evangeline* was written in 1847 and became his most famous work. Over the years, numerous places and things in Louisiana were named after the epic poem: a parish, a community, a brand of gasoline, a movie theater, a racetrack, music and even the area surrounding St. Martinville—the Evangeline Country. The poem described a heartbreaking saga between two star-crossed lovers, Evangeline Bellefontaine and Gabriel Lajeunesse. As the story goes, the two lovers were separated when the British, beginning in 1755, exiled the Acadians from land they had occupied since the early 1600s. They were deliberately scattered to nearly every corner of the globe in hopes they would never reunite. The story follows Evangeline on her odyssey as she crosses the American landscape spending decades searching for Gabriel. Evangeline finally settles in Philadelphia as an elderly woman tending to the poor during a deadly epidemic. She finds Gabriel among the sick, and he dies in her arms.

Perhaps due to the poem's already great length, Longfellow left out key elements—the passage where New Englanders not only furnished men and boats for the deportation, they also helped plan the Acadians' expulsion. However, one thing is certain about Longfellow's *Evangeline*, which deserves high praise: he managed to expose, perhaps unwittingly, the first case of ethnic cleansing in North America, when the British and New Englanders forced the Acadians of old Acadie at gunpoint onto crowded ships bound who knew where. Approximately half died along the way. Although Longfellow

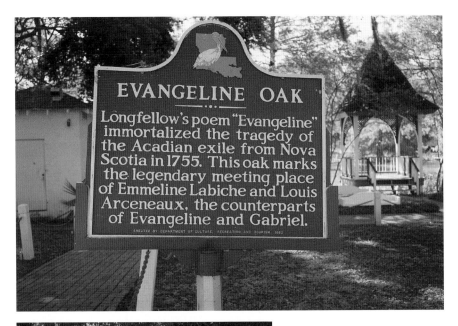

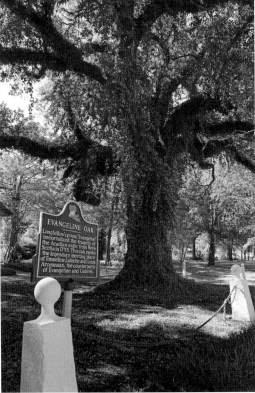

This page: Historic Evangeline Oak on the west bank of Bayou Teche in famed St. Martinville. *Courtesy of Jack Winn collection.*

credits his friend Nathaniel Hawthorne for the epic poem, it's doubtful Longfellow or Hawthorne ever set foot anywhere near St. Martinville. Truth be told, he obtained his information directly from Émile Edouard (Edward) Simon. Edward Simon was a native of St. Martinville, and he was one of Longfellow's students at Harvard. Simon later became a famous judge in his beloved hometown, where he was well known, well liked and a well-respected scholar not known for telling tall tales.

As a young boy, Edward Simon received his early education at Jefferson College in St. James Parish, Louisiana. Afterward, he went to Georgetown College. He graduated in law from Harvard University, and while at Harvard, Simon studied under Simon Greenleaf, one of the principal founders of Harvard Law School and certainly one of the greatest legal scholars of his time. Simon also studied under Judge Joseph Story, who served on the U.S. Supreme Court. And Simon studied American literature with Longfellow, whose work also includes "Paul Revere's Ride." Simon was elected district attorney in St. Martinville and was later elected district judge; he served two terms before the War Between the States. His judicial district was composed of several parishes. He was also a member of the Constitutional Convention

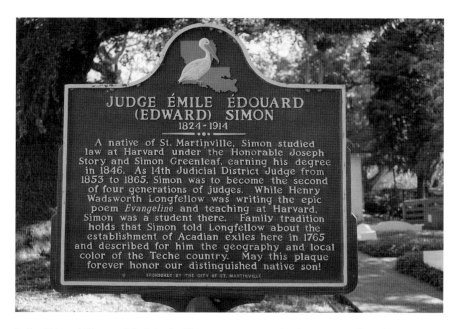

Judge Edward Simon of St. Martinville was never recognized or credited for informing Longfellow of the Acadian exile from which Longfellow created his epic poem *Evangeline*. *Courtesy of Jack Winn collection.*

Bayou Teche, gateway to the Attakapas region, used by early Acadians after their exile from old Acadie. *Courtesy of Jack Winn collection.*

of 1879, after Reconstruction, where he took a prominent role in framing the laws of Louisiana. Judge Simon practiced law until 1911, when his health began to fail. The *Weekly Messenger* of February 14, 1914, published Judge Simon's obituary after he died at his home on February 10 at the age of eighty-nine and nine months. Judge Simon's funeral took place at 4:00 p.m. the following day. He was survived by his six adult children— Eugenie, wife of W.F. Williams of Chicago; Alice, wife of E.W. Bienvenu; Lorena, wife of Edward Suisson; L.O. Simon; Walter Simon; and Judge James Simon. Edward Simon was preceded in death by his beloved wife, the former Harriet Helen Kitchen, who died sometime in the 1880s; his mother, the former Eugenia Zerban; and his father, Justice Edward Simon, a former Louisiana Supreme Court justice and native of Tournia, Belgium.

Longfellow's epic poem had an everlasting effect worldwide, and so did another story: *Acadian Reminiscences*, written by Judge Felix Voorhies and published in 1907. Like Simon, Voorhies was from St. Martinville. He recounted a true story told by his grandmother in which she claimed to be the adoptive mother of a girl named Emmeline Labiche. According to Voorhies, this is the Evangeline that Longfellow had heard of from young Edward Simon and then recreated in his eloquent poem. Judge Voorhies's

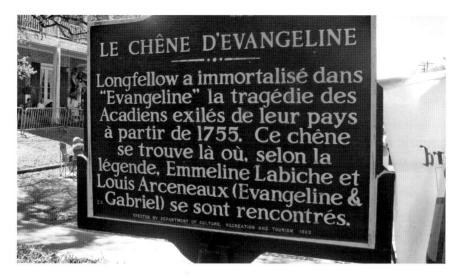

Longfellow's epic poem written in French, the language of the Acadians. *Courtesy of Jack Winn collection.*

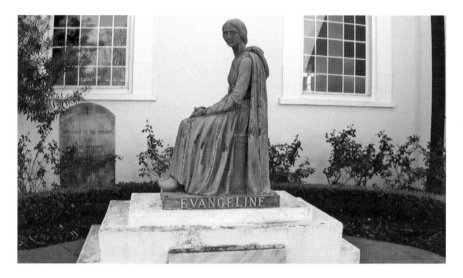

Evangeline statue donated to St. Martinville by actress Dolores del Rio. *Courtesy of Jack Winn collection.*

Longfellow, writer of the epic poem *Evangeline*, on display in St. Martinville. *Courtesy of Jack Winn collection.*

White marble bust of the poet Longfellow in St. Martinville. *Courtesy of Jack Winn collection.*

version of the poem was so moving that in 1929, the movie *Evangeline* was filmed in St. Martinville with actress Dolores del Rio as Emmeline Labiche. In 1930, the actress donated a sculpture of her likeness to St. Martinville. The monument, known as the Evangeline statue, was placed on the site marking the imaginary burial spot of Emmeline Labiche. Over the decades, it has been a popular tourist attraction.

Unfortunately, not everyone felt the same about Longfellow's poem. Long before the 1929 movie, the *Times Picayune* of December 1, 1923, reported that *Evangeline* had become persona non grata with the chairman of the Board of Government from Toronto University. He demanded the removal of *Evangeline* from all Canadian schoolbooks, which formerly held the poem in a place of honor. The chairman said Longfellow's narrative was nothing more than anti-British propaganda. And he stated that "he knows no poem with a more subtle influence to create a wrong, yet an indelible, impression of British justice, chivalry and administration." I would imagine the chairman had a tough time enforcing the ban in the French provinces of Canada.

YELLOW FEVER AND SLAUGHTERHOUSES

The following was written with permission from Jonathan Lurie, one of the authors of *The Slaughterhouse Cases*. Acadiana native Ronald Labbé is deceased, and efforts to locate his family through their publisher have failed. Together, Labbé and Lurie created one of the best history books about New Orleans during the early years. I give high praise to Labbé and Lurie for their excellent book.

During the antebellum period, yellow fever was one of the deadliest diseases to strike New Orleans. Back then, "The mortality rate could reach as high as sixty percent of those who contracted a disease." The death rate in New Orleans ranged anywhere from thirty-six per one thousand in late 1820s to a high of one in fifteen during the summer of 1853. More than twelve thousand people died of yellow fever that year, which marked the highest annual death rate of any state during the nineteenth century. People died faster than graves could be dug. The primary victims of the diseases were immigrants, children, laborers and the poor. Leading physicians branded New Orleans the dirtiest and most unhealthy city in the country. Because New Orleans is below sea level, coffins did not often stay underground but instead floated to the surface. To address the problem, interment in the ground was prohibited. Most south Louisianans were—and still are—buried aboveground. During epidemics, the dead were often buried one on top of another. Deaths were more frequent in urban areas like New Orleans, where large numbers of people packed into smaller areas, which helped spread diseases.

The filth that accumulated in New Orleans polluted the water supply and attracted mosquitoes and other insects. Sailors, especially after the arrival of the steamboat in 1816, helped spread diseases one port at a time. It was a time when immigrants were most welcomed in America. During that period, a large portion of the country was uninhabited; therefore, the nation encouraged immigration. Businessmen and politicians encouraged immigrants to migrate to New Orleans and the surrounding area. They ignored the problem of disease and the death rates. Businesses tried to convince newspapers not to publish negative news or publicize the astounding numbers of deaths. Unlike the poor, wealthy residents of New Orleans could usually escape the diseases by leaving the city during the most dangerous months—June to November. They could also afford better health care and cleaner surroundings.

During that period, scientists weren't aware of what caused many of these diseases. Their cures at that time seem ridiculous today: poisoning stray dogs and activating smoke bombs to supposedly kill harmful disease-causing vapors were tried. All their efforts failed, which led to the establishment of Louisiana's first board of health in 1855. It was the first of its kind in the United States. To reduce the skyrocketing mortality rate, the newly created board of health implemented and oversaw quarantines and public health. Scientists were not certain what caused yellow fever, but most figured it had something to do with mosquitoes and filth. It wasn't until the 1860s that New Orleans demanded a more efficient way of disposing garbage from city markets and slaughterhouses. Cleaning New Orleans came from of a most unlikely source: the general commanding the Union forces, Benjamin Butler. He was shocked at the unsanitary condition—streets reeked of filth, and the stench was unbearable. General Butler ordered city officials to enforce all existing public health regulations. One New Orleans health official testified: "The amount of filth thrown into the [Mississippi] river above the source from which the city is supplied water, and coming from the slaughterhouses, is incredible." Intestines, urine, dung and other animal waste in advanced stages of decomposition were constantly being thrown into the river. All along the Mississippi River for miles, the offensive stench filled the air. Slaughterhouses were plentiful near the riverfront, and back then, every butcher had the privilege of slaughtering on his own property. Butchers generally located in the waterfront section of town. St. Mary Street in New Orleans was given the name Bulls Head, for this was the cattle landing. Up until that time, regulations were sparse, and supply followed demand. As the population moved upriver, so did the operations of the stock providers.

General Butler's successor, Major General Nathaniel Banks, maintained the policy of cleanliness in New Orleans. Incredibly, the city was spared from epidemics throughout Federal occupation. However, when Federal troops left on March 19, 1866, the question arose whether the sanitary conditions would be maintained. It didn't remain an open question for long.

The price for beef in New Orleans in 1867 was sixty dollars a head. By 1868, a local newspaper calculated that there were well over one hundred slaughterhouses in and around the Crescent City. Another reported that a mile or more upstream from the city, one thousand butchers gutted more than a quarter-million animals per year. The city got its water directly from the river, and when in port, vessels filled their water containers from the same source. The city's health officials recommended that Louisiana adopt Napoléon's method in Paris—the establishment of a single abattoir or slaughterhouse for the city. Other large cities had adopted similar measures, which required all slaughtering to be conducted in one public slaughterhouse. The idea of centralized slaughterhouses was not new to New Orleans—in early 1800s, slaughtering had been confined to a small area directly across the Mississippi River known as Slaughterhouse Point in Algiers.

By the mid-1800s, the population in New Orleans had increased tenfold, and for convenience, the slaughterhouses were moved to New Orleans. Following the slaughterhouses were wharves, landings, stockyards and warehouses, and they were established farther and farther upstream. Slaughterhouses gave rise to related enterprises, such as bone-boiling (tallow) factories making candles and soaps and fertilizer plants. These businesses became prosperous and politically influential. On Saturday, February 6, 1869, during Reconstruction, the Louisiana House of Representatives passed the Slaughterhouse Bill by a vote of 51–18. One-third of the House members were either absent or abstained from voting. The bill required New Orleans to establish a centralized abattoir for the city. The Crescent City Live Stock Landing and Slaughter House Company was established. It purchased riverfront property for $48,000 and was located directly across the river from the Algiers location of the early 1800s. The company was granted a twenty-five-year contract for the business and landing as well as for the keeping or slaughtering of animals for food in the parishes of Orleans, Jefferson and St. Bernard. No stock was to be landed, confined or slaughtered for New Orleans markets except at the company's facilities. It had the exclusive privilege. There was one catch: the company was required to have the slaughterhouse constructed by June 1, 1869, and it had to be "a grand slaughterhouse of sufficient capacity to accommodate all butchers."

In short, anyone wanting to slaughter beef had to do it in the new facility, and the company had to permit access to the slaughterhouse to all who wished it.

The act also provided that if the company refused to allow healthy animals to be slaughtered in its new facility, it was to be fined $250 for each case. All animals on the premises would be inspected by an officer appointed by the governor of the state, and an inspector's certification was required at predetermined fees before any animal could be slaughtered. Legal authorities throughout America didn't know what to think of the new law. Was it even constitutional? After the War Between the States, a group of Northerners arrived in New Orleans and began businesses. Naturally, they were against the new law. Not everyone liked or followed the rules. The *New Orleans Republican* of Sunday, July 10, 1870, reported that over half the cattle slaughtered at the newly established abattoir was already dead before the butcher had a chance to bleed the animal. The publication reported: "The meat is red and feverish and not fit for human food, and very often is tainted before reaching market." The article went on to say there weren't adequate slaughtering accommodations required for a city the size of New Orleans. The article continued: "Once the animal was slaughtered, it was thrown on a wagon with several other beeves covered with a tarpaulin, driven to the ferry landing and at times waiting for hours in the hot sun with the meat exposed to the heat." On August 5, 1870, the *New Orleans Republican* reported the arrest of a butcher in Algiers for selling tainted meat. Earlier, a meat inspector from the slaughterhouse had refused to issue a certificate to the butcher, knowing the hog was diseased. Meat from the hog was sold to unsuspecting customers at a Poydras Street market. The same newspaper two years later (March 24, 1872) made the presumption that the proprietors of the *Crescent*, *Times* and *Republican* had received stocks from the new slaughterhouse for their support of the slaughterhouse. The *Republican* was quick to point out that it had opposed the creation of the great monopoly through the passage of the Slaughterhouse Bill.

A battle ensued over the Slaughterhouse Bill, but the lower court ruled in favor of the Crescent City Company in all cases. The three-to-one decision by the Louisiana Supreme Court upheld the lower court's decision. Justice William G. Wyly registered the only dissent, and Rufus K. Howell did not participate. It took opponents three years, but finally six cases were appealed to the U.S. Supreme Court. The butchers based their claims on the "due process, privileges or immunities, and equal protection clauses of the Fourteenth Amendment," which had been ratified by the states five

years earlier. The Fourteenth Amendment had passed with the intention of protecting the civil rights of millions of newly emancipated freedmen in the South who had been granted U.S. citizenship. The slaughterhouse cases were the first interpretation by the U.S. Supreme Court of the Fourteenth Amendment. One of several fatal constitutional flaws in the case, as John Campbell viewed it, was its creation of a monopoly. Campbell had been a justice of the U.S. Supreme Court before the war and had stepped down due to his positive beliefs toward the Confederate states.

April 14, 1873, was the eighth anniversary of Lincoln's assassination. Grant had just started his second term in office, and in a nearly empty courtroom, Justice Samuel F. Miller delivered the 5–4 decision against the New Orleans butchers in the slaughterhouse cases. The U.S. Supreme Court held a narrow interpretation of the Fourteenth Amendment and ruled that it did not restrict the police powers of the state, and the butchers' rights had not been violated. The slaughterhouse cases have always been considered some of the greatest constitutional cases in American jurisprudence. When Miller announced the Supreme Court's decision, Reconstruction in Louisiana was about to crumble. There were race riots in both New Orleans and Colfax, the latter only days before the court announced the slaughterhouse decision.

National and state elections in November 1876 marked the end of Reconstruction in Louisiana with Confederate veteran Francis T. Nicholls elected as governor. Federal troops were withdrawn from Louisiana the following year, and the Supreme Court's slaughterhouse decision was short-lived. Within three years, the Louisiana Constitution of 1879 did away with granting special provisions such as creating corporations or granting exclusive rights, privileges or immunity to any corporation. The new Louisiana Constitution gave parish and city governments exclusive authority to regulate slaughtering and the keeping of livestock. They could not do so by means of a monopoly, and slaughtering had to be done with the approval of the board of health. Article 258 repealed the Crescent City Company's exclusive franchise of slaughterhouses, which opened the door for private slaughterhouses. Old habits die hard. Butchers requested to return to the locations from which they had been removed in 1869. They were strongly opposed by the waterworks department.

In 1893, a year before the Crescent City Company's twenty-five-year charter expired, it was rechartered as the Crescent City Livestock Yard and Slaughter House Company. The slaughterhouse was located near Jackson Barracks in New Orleans's Lower Ninth Ward. It was an enormous development that began at the water's edge on the Mississippi River,

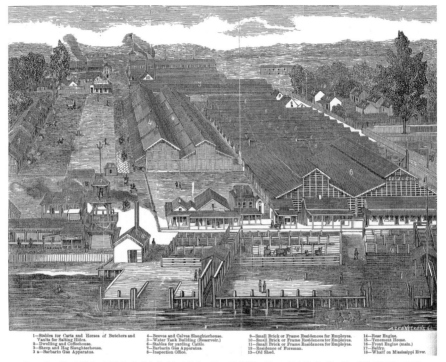

1—Stables for Carts and Horses of Butchers and Vaults for Salting Hides.	4—Beeves and Calves Slaughterhouse.	9—Small Brick or Frame Residences for Employes.	14—Rear Engine.
2—Dwelling and Coffeehouse.	5—Water Tank Building (Reservoir.)	10—Small Brick or Frame Residences for Employes.	15—Tenement House.
3—Sheep and Hog Slaughterhouse.	6—Stables for yarding Cattle.	11—Small Brick or Frame Residences for Employes.	16—Front Engine (main.)
3 a—Barbarin Gas Apparatus.	7—Barbarin Gas Apparatus.	12—Residence of Foreman.	17—Belfry.
	8—Inspection Office.	13—Old Shed.	18—Wharf on Mississippi River.

Source: *Annual Report of the Board of Health of the State of Louisiana to the General Assembly, 1875.* New Orleans, printed at the Republican Office, 1876, photos follow page 246.

Image Provided courtesy of the Louisiana State University Health Sciences Center Libraries – New Orleans, LA.

Copyright © 2005 LSUHSC-New Orleans

An 1876 diagram of the Crescent City Livestock Landing and Slaughterhouse Company. *Courtesy of Louisiana State University Health Sciences Center New Orleans Libraries.*

extended away from the river for a couple of city blocks and followed the river for perhaps a mile. In one way or another, the company continued to operate in the same location until the 1920s. On June 6, 1963, the *New Orleans Times Picayune* reported the closing of the New Orleans Butchers Cooperative Abattoir due to labor disputes and dwindling supply of cattle and the expansion of local neighborhoods into former pastures. It had operated for sixty years, and it was the last slaughterhouse in the New Orleans area. It is now a middle-class neighborhood. Street signs in the area still bear the names of some of the butchers and stock dealers who first began the slaughterhouses, such as Esteben, Aycock and Mehle.

CLAIMS FROM SOUTHERN LOYALISTS

On March 3, 1871, six years after the War Between the States ended, the Southern Claims Commission was created by an act of Congress. Thousands of Southerners filed claims against the U.S. government for various items, such as cotton, sugar, cattle, hogs, horses, saddles, bridles and a number of other things that had been requisitioned by Federal forces. The Claims Commission was sometimes called the "Cotton Claim," because most of the claims were for the cotton that was taken from many of the Southerners. If you were a Confederate sympathizer, your claim was as good as Confederate money—worthless. You had to have been loyal to the Union to be compensated for your losses. Acts of disloyalty disqualified a claim—voting for secession and holding civil or military office during the Confederacy disqualified claimants. Furnishing aid to the Rebels of any type was another reason to be disqualified. However, "claimants who had served in the Confederacy involuntary or had been drafted, served a short time, deserted at the first opportunity, enlisted in the Union Army and were honorably discharged, their claims were granted," according to *The Southern Claims Commission*, written by Frank Wyson Klingberg. And that was about as rare as hen's teeth. Five days after Congress passed the act to create the commission, President Grant named three commissioners to oversee the process. They were all Republicans: Asa Owen Aldis of Vermont; Orange Ferriss of New York; and James B. Howell of Iowa. Prominent attorney Asa Aldis was named president by virtue of having served on the Vermont Supreme Court, and he had been trained in judicial procedures

of international law. The other two commissioners had both served in Congress. Salaries for these positions in 1875 was $5,000 per year, and the commissioners had free rein in what they considered loyalty.

On May 17, 1871, the commissioners announced that they were ready to begin public hearings on claims already on file on Tuesdays, Wednesdays, Thursdays and Fridays. Saturdays and Mondays were reserved for debate on whether the applicant had a valid claim or not. It was far easier—and certainly more profitable—to be loyal after the rebellion than before the conflict. So each person submitting a claim had to submit to a loyalty test. From the very beginning, the claimants were guilty of disloyalty unless they could prove otherwise; the burden of proof was on the Southerners. Claimants were called to swear that they had conducted themselves as loyal citizens of the United States and had not given aid or comfort to the Rebels. They had to prove that they were against secession not only before the war but also during Federal troop occupation. Once a claim had been approved by a field agent, it was forwarded to Washington for intensive scrutiny by the three-man board. Any two members of the board constituted a quorum, and any of the two could decide any controversy. Claims needing further investigating were reopened. The act required factual numbers to be recorded in a journal showing the date and name of claimant with all other pertinent information, along with signature of the president of the board and the amount of the claim awarded, if any.

Finding suitable field agents was a difficult process. They were mostly justices of the peace, and they had to travel from town to town usually in hostile surroundings—they represented the federal government and were there to disprove claims. According to *The Southern Claims Commission*, "Scattered in warehouses in Virginia dusty packs of folded claims poured into the claims' office with tens of thousands of pages of oral testimony, covering interviews and statements of persons ranging from the humblest members of society to key figures of government." Anyone reading Klingberg's book should certainly read the footnotes—they're a treasure-trove of valuable information for any researcher.

Special provisions were made for cases under $10,000—the government held court at convenient locations throughout the South. For claims exceeding $10,000, however, the government employed what some would call a wearing-down process. Claimants were required to appear in person in Washington with witnesses along with documents to prove their cases. Some claimants brought their attorneys, who usually charged 50 percent of the claim. Attorneys usually agreed to bear expenses connected with hearing

the cases and accommodations. It didn't matter what was written on the claim form, the commissioners wanted to see how the claimants appeared on the stand and how they responded. A lengthy eighty-question list was used for the claimants and witnesses. The Southern Claims Commission recorded 22,298 petitions claiming more than $60.25 million by loyal Southern Unionists. There were 220,000 witnesses who testified either for the claimants or for the government. Louisiana led the South with more than $8 million worth of claims—more than twice the amount of the second highest, Mississippi, which was closely followed by Virginia. For every claim approved, approximately five were denied or disapproved. Letters from Union officers often condemned the messy accounting practices used for obtaining supplies during the war.

Sometime claims were reversed, and individuals owed money to the Federal government, as was the case when New Orleans fell in the spring of 1862. On May 1, Federal troops took over the NOO&GW Railroad in New Orleans. When the war ended, Federal troops continued to operate the railroad. There were numerous delays in returning the railroad to its rightful owners. All of this time, the NOO&GW had never received a penny of revenue for the nearly five-year period of military occupation. Military authorities would not return the railroad except on terms the directors of the railroad refused to accept. The glitch was over rolling stock, which had been taken by the Federal troops during the war and given to other railroads operated by the military. The railroad directors insisted that the rolling stock was their property and should be returned to their road, to which the military authorities objected. To make matters worse, according to Southern Pacific Bulletin of October 1952 (page 46), "The War Department presented the railroad with a bill for $113,773.00 which the government claimed was owed them for items purchased for its operation including everything from locomotives to feather dusters." The railroad wasn't returned to its rightful owners until February 1, 1866, long after the end of armed hostilities.

There were several methods to file a claim. There was the French and American Claims Commission, the Mixed British and American Claims Commission, the U.S. Claims or the Southern Claims Commission. Klingberg wrote that some claims at the National Archives were very lengthy; many of them ran into the hundreds and even thousands of pages. In Louisiana alone, and especially in the Acadiana region, more than two thousand individuals took their grievances to court. On April 3, 1874, Dr. John Rhodes of St. Mary Parish submitted a claim for $59,650. He told the claims commissioners he had kept his sugar on his plantation instead

of marketing it or surrendering it to the Confederate authorities, "relying fully on President Lincoln's proclamation that all those who didn't commit themselves in any shape in aiding or assisting the Confederates should be compensated for the loss of their property." Dr. John Rhodes had kept his obligation and was allowed $21,971, or about one third of his original claim, and he was compensated the same year he filed his claim.

From the beginning of the war, Lincoln offered every assurance that the rights of loyal Southerners would be preserved. He provided a full pardon and restored all rights of property except for slaves to Southerners who would faithfully support, protect and defend the Constitution of the United States. Lincoln's objective after the war was for a speedy reunion. His condition for state recognition required an oath of allegiance to the United States by at least one-tenth of the total votes cast at the presidential election of 1860. Those were the plans for Louisiana, Arkansas, Tennessee and Virginia, but Congress refused to admit their representatives sent to Washington. The terms were acceptable to loyalists as well as the ever-increasing numbers of discouraged Confederates. Klingberg and other historians maintain that the South was ready immediately after Appomattox to accept in good faith "its failure in establishing the right to secede, to deny war debts, and looked forward to full reinstatement within the Union in compliance with the armistice terms."

One of the more noted claims filed from Acadiana came from Jules Perrodin, a successful merchant from Opelousas. Perrodin was a native of France, and at the time of the war, he was not a U.S. citizen—he was neutral. It did little to deter the Union army from taking his property. Perrodin submitted a 238-page claim that read like *Gone with the Wind*. His story was published in a 1955 *Daily World* article and again on July 29, 1982, titled "Jules Perrodin vs the U.S." The Battle of Bayou Bourbeux was talked about in the testimony of Constance Guidry, wife of Thelismar Guidry, who was serving in the Confederacy at the time. The other witness was Augustin Domingue, who had been a slave at the Guidry plantation and had stayed on as manager. According to the article, the Battle of Bayou Bourbeux was fought near the Guidry home on November 7, 1863. After the battle, the home was used as a Yankee hospital, and Jules Perrodin's cotton was used as makeshift mattresses. According to the article, some of Perrodin's cotton was sent to other plantations in the area and used in the same manner.

Constance Guidry testified for Perrodin, saying that she had personally witnessed Northern troops loading wagons and carrying off the cotton. She had even informed the Union officers, including a Lieutenant Pollard,

that the cotton had been bought and paid for by Jules Perrodin, a neutral merchant. Pollard reportedly said Perrodin would be better satisfied knowing his cotton was in Union hands. Augustin Domingue's testimony was about the same as Constance Guidry's, but he added that General Cuvier Grover of the Federal army had his tent in the yard near the steps leading into the Guidry home. Opposing counsel for the claims commission made much about Jules Perrodin, indicating that he gave aid and comfort to the Confederates. Perrodin maintained that he had kept strict neutrality as befitted his position as a neutral French citizen. After all, he was a successful businessman and couldn't afford to be biased one way or another. It just wasn't good for business. Perrodin was represented by the French Republic.

Union colonel Thomas E. Chickering of the Forty-First Regiment of Massachusetts Volunteers was military governor of St. Landry Parish during Federal occupation. In his deposition, taken in Boston in 1870, he said he was under orders from his superiors to gather "cotton, sugar, and other products of the country." The merchandise was shipped from Washington and Barre's Landing (Port Barre) to New Orleans and from there to Europe, where the cotton was sold on the world market. The original act allowed two years for the settlement of claims. The deadline was extended several times until the final date of March 1880. Jules Perrodin never gave up; his case was first filed in 1866. It was reopened in 1881, a year after the last extended date. Jules Perrodin's claim was finally decided in his favor on legal merits, but not before many years of frustration. The enormous mass of records of the Southern Claims Commission preserved not only stories of courage by Southern Unionists but also of their betrayal.

Rails West

For generations, people have asked why Louisiana railroad builders chose the route from Algiers, across the Mississippi River from New Orleans, to Morgan City and Lafayette. Although ownership of the rail line has changed numerous times over the years, the route has stayed the same. It was originally named the New Orleans, Opelousas & Great Western Railroad, which later became part of the Southern Pacific Railroad. The entire line from New Orleans to California was made up of numerous smaller railroads. The NOO&GW was the second oldest of all the railroads that combined to make up the Southern Pacific system.

Railroads have been in America since the 1830s, about fifty years after the first cattle drive from Texas to New Orleans. Back then, there were only a few miles of railroads in Louisiana, but they weren't all connected and probably weren't very functional. On March 11, 1851, a group of New Orleans businessmen and representatives from various parishes proposed to build a railroad from New Orleans west. Former governor Alexandre Mouton was one of the main supporters. At that time, New Orleans stood at the crossroads of America; it could have been the commercial center of the United States. The city ranked fourth in population, and it was competing with New York for the number-one spot as the largest port city in the nation.

Two rail routes were proposed, and both were to originate in New Orleans, with one going north to Nashville and the other to Opelousas in St. Landry Parish. The Louisiana legislature was asked to abolish certain laws and to adopt others more conducive to facilitating and promoting the immediate

construction of railroads. The legislature enacted laws that permitted the railroad to expropriate lands if necessary for rights-of-way. Fortunately, at that time, most Louisiana residents wanted a rail line. George Willard Reed Bayley was Louisiana's assistant state engineer. He was asked to direct the 1851 survey to find the most feasible route for a railroad from the Mississippi River to the Sabine River. Albert G. Blanchard, a former Louisiana teacher, was chief of the engineering party. Civil engineer Augustus S. Phelps was second in command. They were assigned the task of finding a path for the first section of railroad from Algiers to Berwick's Bay, about eighty miles southwest of New Orleans. Blanchard took the most difficult portion— Algiers to Thibodaux. Phelps, assisted by Dr. W.S. Smith, went from Thibodaux to Berwick's Bay. They made a survey of the proposed rail route in detail. The surveyors trekked the swamps and what they referred to as trembling or floating prairies, crusts of earth floating or suspended on water capable of holding a man's weight.

Prairie reeds and other vegetation grew thick and as high as 12 feet. Sometimes it took an entire day to travel only a few miles. While on their trek, the engineers recorded the types of trees in the swamps, mainly cypress, tupelo gum, ash and maple. They also viewed the crevasse watermarks on trees to determine how high the roadbed needed to be to stay above flooding. Watermarks were usually 3 to 4 feet high. When the engineers came upon a large body of water, they took measurements. Bayou Boeuf was reported to be "19-2/3 miles from [Bayou] Lafourche." Bayou Boeuf was measured to be 590 feet across, both sides of its banks were 8 feet above the surface of the water, and it had a gentle current each way according to the tide. The difference between ordinary high and low tides was about 18 inches. The depth of the bayou was 15 feet at low tide.

The surveyors also examined the soil. In one location near Bayou Boeuf, the engineers dug six to twelve inches below the surface of the earth and reported that the soil was "tolerably firm," being clay or what the Acadiens called *terre gra*. They determined that about half of the entire length (between Thibodaux and Berwick's Bay) had never overflowed. The other half was on land subject to flooding from one to four feet in times of extremely high water caused by levee breaks on the Mississippi River. The men estimated that cutting trees and clearing a roadway for the twenty-five-mile section would cost $9,000. All embankments and grading were estimated to cost $37,000; crossties $32,000; and spikes, tie plates and sixty-three-pound rails (per lineal yard) $145,000. An additional $1,200 per mile was estimated for the construction of bridges, culverts, depots and warehouses in the twenty-

five-mile section. A 10 percent charge was added for engineering costs, making a total of $244,596, or $9,144 per mile of track.

Many engineers of that era had the opinion that the best manner of building a railroad across overflowed swamp was to construct a trestle or bridge. However, these railroad engineers felt that a more substantial and cheaper roadbed could be obtained by building a solid embankment of earth. Their estimated cost for building the embankments was based on constructing it more than one foot above the highest crevasse watermarks. A.G. Blanchard, the lead surveyor, wrote from his personal examination and from information derived from every source available to him at the time—planters, hunters, fishermen and travelers—who all agreed on his observation. He recommended this route as the best to the west.

Railroad construction on this line began at Algiers on October 8, 1852, under the direction of chief engineer G.W.R. Bayley of Louisiana. It was decided that the track gage (gauge)—the distance between railhead to railhead—would be five feet, six inches for the new railroad. At the time, they believed that all subsequent rail lines west of the Mississippi would follow suit. With considerable optimism, the contract called for the completion of the entire rail line to Washington, Louisiana, by January 1, 1855. The organizers of the railroad intended to extend the line along the 32^{nd} parallel westward to Texas and the Pacific. It was a daring undertaking to say the least. The railroad had to be built on hand-driven piles over snake- and alligator-infested swamp. Railroad construction gangs consisted of Irish and German immigrants paid $26 per month.

Heat, dirty swamp water and mosquitoes added to the discomfort of the men, who often had to work in mud and water up to their waists. In 1853, nearly seven hundred men were employed when the yellow fever epidemic decimated construction crews, which caused major delays. Floods occurred often, lasting six months in some cases. Financial problems caused an even bigger hurdle to overcome. The railroad's first locomotive was lost off Key West, causing additional delays in opening the road to actual operation. Originally scheduled to arrive in March 1853 and costing $6,000, the twenty-ton wood burner built by the Baldwin Company was not delivered until September. Upon its arrival, it was named the *Opelousas*. It was the least expensive locomotive to ever run on the NOO&GW. It was immediately put to work hauling trainloads of ballasting material for the contractors.

By the end of 1853, there were eight passenger cars, two baggage cars, ten boxcars, twenty-five flatcars and ten railroad handcars, along with enough rails for 215 miles of road. Severe financial problems continued.

Logging with oxen as it might have looked in 1850s. *Courtesy of Bevan Bros. Photography.*

Railroad construction gangs were employed on a month-by-month basis. Bates Benson & Co. had been kept on for the completion of the railroad over the trembling prairies, primarily between Bayou Des Allemands and Bayou Lafourche. By February 24, 1856, the entire section was completed from Algiers to Bayou Boeuf. Things were looking bright for the railroad. However, the old problem of insufficient working capital was looming once again. Construction costs had far exceeded the original estimate of $9,000 per mile. The actual cost averaged $36,000 per mile of track. On November 13, 1856, the founders of the railroad reached an agreement with Cornelius Vanderbilt for steamship service between the terminal at Brashear City and Galveston, Texas. Meanwhile, the company had scraped together enough cash to hire contractors to build the railroad up to Berwick's Bay, which was completed on April 12, 1857. When the railroad was opened for rail traffic, numerous people refused to ride over the swamps and trembling prairies, fearing that the track would sink out of sight under the weight of the trains.

A wharf was completed by the middle of May 1857. Large cattle pens were built to take care of livestock shipments. Dormitories for train crews were also built, along with a house for station agents, sidetracks, turntables and other facilities, including the shops at Algiers. Elsewhere on the rail line, depots, platforms and pumping stations were being built. Every ten miles or

so, water tanks or water towers were built to accommodate steam engines. Barges were purchased for handling freight across the Mississippi River at Algiers. A twice-weekly boat train matching the ship's schedule had also begun. Rail passengers back then boarded a ferryboat at the foot of St. Anne Street, only blocks from what would eventually be known as Jackson Square. Once across the Mississippi River, rail passengers disembarked at Algiers, where they crossed the levee and walked one block to the railroad depot located on the corner of Thayer Avenue and Verret Street. The process of crossing by rail ferry continued until 1935, when the Huey P. Long Bridge was built.

In addition to the regular daily train from New Orleans, sternwheeler connections were also available for New Iberia and other points on Bayou Teche. For unknown reasons, Vanderbilt sold his steamship lines to Charles Morgan. Despite a depression, business on the railroad was good during the first three months of 1858. However, no further progress could be made until adequate capital could be obtained. The railroad managed to sell enough of its bonds to hire a contractor to start the grade work west of Berwick's Bay. A four-foot-high embankment was built across the swamps and marshes on the west side of the bay, while grading work started between New Iberia and

Loading produce onto railcars. *Courtesy of Bevan Bros. Photography.*

Vermilionville (Lafayette) before the end of 1859. Prospects looked good for an early completion of the rail line across the state.

Unlike other waterways on the rail line, there wasn't a contract arranged for the crossing of the Atchafalaya River at Berwick's Bay—some 1,740 feet across and from 60 to 80 feet deep at mean or average tide. While a bridge at this point was deemed a necessity by the company, many people considered it an impossibility. Ferries were employed to cross the railcars much like what was done between New Orleans and Algiers. Like all railroads, it needed constant maintenance to keep it up to grade. However, insufficient drainage coupled with inadequate ballast made it a chronic problem to maintain. In 1860, drainage ditches were dug for miles along the roadway, and almost 40 percent of the ties were replaced with heavy cypress crossties that were 11 feet in length by 12 inches wide. Business on the railroad was good in 1860 via railroad and steamship connections. The *Cricket* and the *St. Mary* were riverboats that plied Bayou Teche from Brashear (Morgan City) with stops at Pattersonville, Centerville, Franklin, Charenton, Jeanerette and New Iberia. From there, the steamers connected with Powell, Taylor & Co., which was billed as an "elegant double daily four horse post coach" to all points.

On January 26, 1861, Louisiana seceded from the Union and joined the Confederacy. By the end of the year, the roadway and grading work was completed along with a telegraph line from Algiers to New Iberia, a distance of 125 miles. The roadbed was ready for track building between Berwick's Bay and Vermilionville. The first batch of cypress crossties was shipped for the 63-mile section. However, a blockade by Union forces prevented delivery, which effectively put an end to railroad expansion for the duration of the war.

New Orleans fell on April 25, 1862. A week later, the NOO&GW was taken over by Federal troops. The railroad was finally given back to its rightful owners on February 1, 1866, about four years after the road was first taken over. To add insult to injury, the railroad was presented a bill for $113,773 covering all expenses incurred by the Federal government, including everything from locomotives to feather dusters. No maintenance had been performed by Union forces, and despite all the railroad's efforts, it proved too much to overcome. On May 25, 1869, Charles Morgan purchased the railroad at auction, including all property west of Berwick's Bay, for a total of $2.3 million. The romantic-sounding NOO&GW ceased to exist. It was then named Morgan's Louisiana & Texas Railroad. The Louisiana legislature approved $6 million to construct the line.

Brown News, Southern Pacific headquarters around the 1930s. *Courtesy of Lafayette Parish clerk of court Louis J. Perret.*

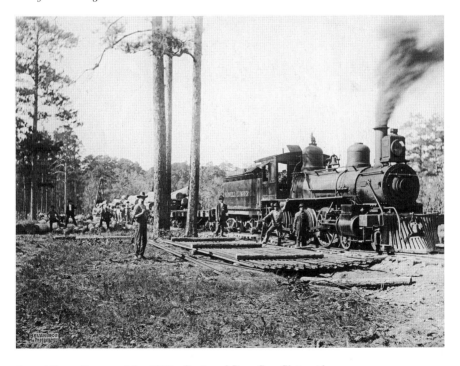

Assembling rails around the 1920s. *Courtesy of Bevan Bros. Photography.*

In July 1872, Charles Morgan changed the track gauge from five feet, six inches to four feet, eight inches, the standard throughout the American rail industry today. Interestingly, the track tools used back then are still in use today. All of Morgan's ships had his five-point star on their smokestacks. He continued that practice on the railroad by fashioning his star at the front entrance of his railroad offices and depots and on the nose of locomotives. Truth be told, Texas got its star from Charles Morgan when he delivered gunpower to the Texans prior to 1835, when they won their independence from Mexico. In 1876, Brashear was changed to Morgan City in honor of Charles Morgan. Construction west of Berwick's Bay began during the summer of 1878. By this time, Morgan City had been the NOO&GW Railroad's westernmost terminal for twenty years. Unfortunately, Charles Morgan died at eighty-three years of age on May 8, 1878, while at his home in New York City.

May 17, 1879, was the day the Louisiana Western Railroad signed the charter to begin construction from Vermilionville (Lafayette) to the Sabine River following the Old Spanish Trail upon a line between Louisiana and Texas, as required by agreement. An affidavit was signed by J.G. Parkerson, an agent of the Louisiana Western Railroad. Parkerson had confirmed that most of the land on the proposed rail line was unimproved and uninhabited. The affidavit also mentioned that the railroad had diligently made efforts to ascertain the names of the owners of real estate and to acquire title of same. Two hundred feet in width was the stated amount of land necessary for building the railroad, which in most cases is the same today. The first trains from the east reached Vermilionville in March 1880. Work on the railroad toward Cheneyville, in central Louisiana, continued simultaneously while working westward.

This new mode of transportation opened the area for rapid settlement, transforming small communities into thriving cities. The arrival of the railroad created a multitude of jobs that had never existed before. Railroads hired locals who helped grading gangs prepare roadbeds and rights-of-ways, which were usually fifty feet wide from the centerline of track. Some helped build embankments for the railroad, while others worked for bridge gangs building depots, office buildings and bridges over the numerous bayous and waterways. Bridge gangs also built culverts at intervals to divert water away from the roadbed. Hundreds of trackmen, often referred to as gandy-dancers, used picks, shovels, wheelbarrows and horses to dig ditches on either side of the track for drainage. They also spiked rails onto evenly spaced, hand-hewn wooden crossties.

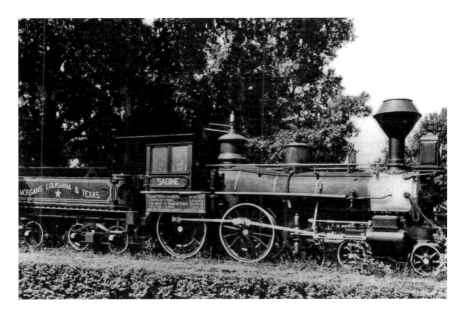

The *Sabine*, the engine that pulled the first train into Lafayette, 1880. Notice Morgan's five-point star on the tender. *Courtesy of Lafayette Parish clerk of court Louis J. Perret.*

Regardless, there were some who weren't satisfied. Many landowners felt the railroad was taking their land for railroad use and they weren't being compensated. Most seemed to have forgotten that in 1852, nearly three decades earlier, they had eagerly signed documents allowing the railroad rights-of-way to construct the rail line through their property. According to an article written by Dr. Maureen Arceneaux, many landowners felt the railroad was a huge inconvenience. Their farm animals were killed or injured by passing trains. Some were obligated to build fences along the railroad to protect their animals. Farmers complained that at times railroad section hands damaged the fences or left gates open. Farmers complained about the threat of fire from the smoke-emitting locomotives or from overheated journal boxes, which at times would set fires to grass along the fences bordering the right-of-way. Sometimes fires would also spread to crops and outbuildings and even to homes along the railroad. Another constant complaint (which still exists today) was that there were too few grade crossings, and the ones that existed were too narrow and elevated, making it difficult to cross. Some farmers complained that passing trains caused their farmhands to stop work. Hobos trespassing onto the railroad would often vandalize property. Lawsuits were filed by landowners, but railroad attorneys argued that sometimes through progress things happen. They also countered

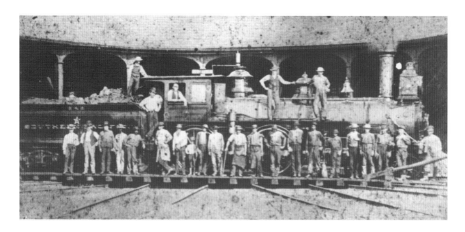

The Lafayette roundhouse, 1888. Notice Morgan's five-point star on the tender. *Courtesy of Lafayette Parish clerk of court Louis J. Perret.*

by explaining how the distance to ship goods and services was shortened. Sometimes the railroad attorneys were fortunate—they were able to find a farmer to testify about fewer miles to travel and how much cheaper freight and merchandise were due to the railroad. Witnesses for the company testified that land value had increased with the arrival of the railroad. Even the cost of coal dropped substantially. Farmers and townsfolk alike had to agree that since the arrival of the rails, new and better-paying jobs were available. Most of the citizens had been in favor of the railroad since its inception. Others wanted a rail line, they just didn't want one on or next to their property. A decision was rendered and the landowners won the lawsuit on the local level, but the judgment was reversed by the Louisiana Supreme Court.

August 28, 1880, was the date of the first through train to reach New Orleans from Houston. Less than six months later (February 4, 1881), the first train crossed the Berwick's Bay bridge, newly built at a cost of $265,000. The impossible had been achieved. Also, 1881 saw the completion of the second transcontinental railroad, of which the former NOO&GW was a part. The transcontinental railroad shortened cross-country journeys from six months to one week! It was truly a quantum leap in transportation. In 1884, Morgan's Louisiana Western Railroad was taken over by the Southern Pacific Railroad. The age-old question, why was the railroad constructed on this route where it currently stands, can be answered—it paralleled a pathway used by early Spanish explorers and immigrants pushing westward. It was a familiar route—people used it. And it was alongside the Old Spanish Trail, used to herd cattle to New Orleans markets in the 1700s.

THE PECULIAR CASE AGAINST DORA MURFF AND JAMES DUVALL

I t's been well over one hundred years since the high-profile murder case against Dora Murff and her stepfather, James Duvall. In 1913, if it wasn't the most talked-about murder case on the prairies of southwest Louisiana, it was certainly the most expensive case in Acadia Parish. It cost a whopping $500 per day—the price of a new automobile! The trial lasted thirteen days, and as promised, it was a sensational court battle. It was also said to have a remarkable display of legal talent on both sides of the aisle. Adding to the fray was Judge William Campbell of the Eighteenth Judicial District holding court until the wee hours of the morning. Even the U.S. Supreme Court had a hand in the matter. According to the census figures for that period, there were approximately 5,500 persons living in Crowley, where the incident happened on Parkerson Avenue between Fourth and Fifth Streets. John Delhaye was accused of "having betrayed Dora Murff under the promise of marriage." It was alleged that after seducing Dora, Delhaye promised to marry her, but he didn't keep his promise.

After becoming discouraged, Dora, in a state of depression and thinking her life was ruined, attempted suicide by drinking an entire bottle of horse liniment. Dr. A.B. Cross was called to treat the young woman shortly thereafter. She had no ill effects from her apparent suicide attempt. The following night, which was a Monday, James Duvall and his fourteen-year-old stepson, Allie, also known as Buddie, paid Delhaye a visit at the ice plant where he worked as an engineer. Duvall demanded that Delhaye marry his stepdaughter or he would kill him. The following day, a peace bond

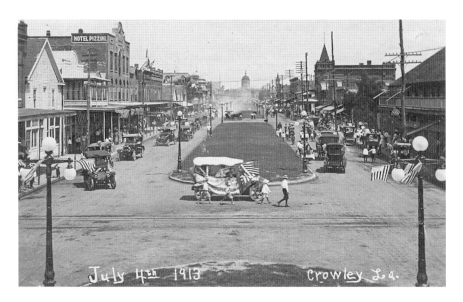

Looking north on Parkerson Avenue in Crowley. Note the courthouse at the end of the street. *Courtesy of Freeland Archives, Acadia Parish Library.*

was issued against Duvall and Allie. They were warned to stay away from Delhaye and were ordered to pay a fine for their threatening statements.

On the evening of Wednesday, October 15, 1913, James Duvall, Dora Murff and Buddie Murff were seen riding up and down Parkerson Avenue in a horse-drawn buggy apparently looking for someone. Witnesses stated they saw a shotgun on the front seat next to Duvall. The streets of Crowley were alive with activity, especially Parkerson Avenue, Crowley's main street. A horde of people was going to the "moving pictures" at the Grand when James Duvall's buggy drove up to the curb near B. Meyer's store, where Delhaye was walking. That was when Dora called out to him to wait. She wanted to speak with him. John Delhaye paused a second or two to see who had called out to him, then hurried south. The desperate girl called for Delhaye to stop or she would shoot. Delhaye started to run. The sound of a gunshot rang out, and Delhaye staggered and fell to the pavement "in agony of death," said one witness.

This is where it gets confusing. At just about the same time that the gunshot rang out, Dora jumped from the buggy and ran after her fleeing lover, firing a revolver twice. As her victim fell, Dora threw herself onto Delhaye and began kissing him while at the same time shouting, "I've killed him." At that time, Dora still held the weapon in her hand as curious onlookers scattered

from the scene. Dora's stepfather approached and tried to calm the fears of the crowd by saying, "It's alright gentlemen; the gun is not loaded." Hadn't she just fired the gun and stated that she had killed her lover? How did Duvall know the gun was empty? Those questions and others would come back to haunt them.

Meanwhile, John Miller Delhaye was taken into the Avenue Pharmacy, where he died within a few minutes. Delhaye had a small-caliber, five-shot Smith & Wesson revolver on his person at the time of his death. James Duvall, Dora and Allie Murff were immediately placed under arrest, and the coroner was called. A coroner's inquest resulted in the jury bringing in a verdict stating that John Delhaye was killed by a shotgun blast from the hands of James Duvall. It was claimed that Duvall and his son carried the shotgun as a matter of self-defense due to claims that Delhaye was armed. It was also alleged that when Dora called out to her lover, he reached into his pocket, and they believed that Delhaye was going for his weapon.

Did Dora fire the shotgun that resulted in Delhaye's death? The coroner wasn't buying it, and his verdict charged Duvall with firing the fatal shot. Numerous eyewitnesses claimed that Duvall had fired the weapon. John

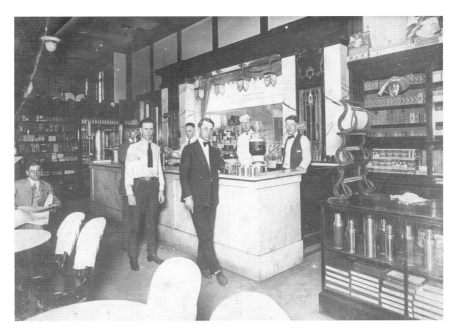

Eckels Drug store around 1921. This might have been what Avenue Pharmacy looked like in 1913. *Courtesy of Freeland Archives, Acadia Parish Library.*

Delhaye was a native of Franklin, Louisiana. He was employed as an engineer for the ice plant in Crowley. Delhaye was reportedly well liked in the community. He and Dora's association dated back several years, probably all the way to Franklin in St. Mary Parish. It was going to be one heck of a trial trying to decipher who did the actual shooting. To borrow a line from *Shawshank Redemption*, "It was one hell of a case, all right. It was one of those juicy ones with all the right elements." It had a beautiful girl with society connections and a prominent young businessman with a bright future ahead of him, it had all the scandal the newspapers could hint at, and there was the prosecution with a not-so-open-and-shut case.

Phillip Pugh, the defense attorney, requested that the courthouse be guarded due to numerous rumors floating around that the defendant would not leave the courthouse alive. Judge Campbell took it under advisement and then replied that he didn't think such a move was necessary and that he didn't pay much attention to rumors. However, he assured Pugh that he would provide a safe and secure place for the prisoners while in the custody of the State of Louisiana. Pugh wasn't satisfied; he asked Judge Campbell to order a search of every person in the building for deadly weapons. Again, Pugh was overruled. The judge calmly stated that no jurors were drawn from Crowley because of threats made against James Duvall. It still didn't bode well with Pugh, but he remained silent. Pugh had reason to be worried. Back during that era, Acadia Parish was known to be partial to vigilantism, and roadside justice was frequently administered. The area was considered by many to be the most dangerous place in Louisiana. Despite what Judge Campbell told Pugh, when jury selection was completed, about 30 of the jurors were from Crowley. The others were reported to be from Rayne, Church Point and other neighboring towns of Acadia Parish. The selection of the 12 jurors exhausted the pool of 150 perspective jurors Sheriff Louis Fontenot had brought in at the start of the trial.

Judge Campbell was one step ahead of the defense attorney. He had ordered an extra panel of 150 jurors to the objection of Phillip Pugh. The court overruled his objection, and the defense filed an exception. Many of the prospective jurors were excused because of their lack of understanding of the English language. This was southwest Louisiana, and at that time, French was the primary language spoken by nearly everyone. Other prospective jurors were dismissed after stating they would never hang a girl. Some of the men didn't know the meaning of "reasonable doubt" and other expressions used by the lawyers. The defense attorneys seemed to be partial to jurors who were married with children, especially daughters.

Acadia Parish Courthouse, where the Murff and Duvall trial was held. *Courtesy of Freeland Archives, Acadia Parish Library.*

A jury of twelve men was finally selected—women wouldn't be allowed on juries for at least another generation. The jurors were R.H. Stagg, Estherwood; Girard Hoffpauir, Estherwood; Sidney Savoie, Church Point; Jules Brisco, Church Point; M. Miller, Iota; J.J. Castille, Rayne; S.V. Guidry, Midland; Clay Richard, Church Point; Laurent Thibodeaux, Church Point; Willie Johnson, Castille (later known as Mire); Luther Harkin, Rayne; and Louis Richard, Church Point. The prosecuting attorneys were Cassius B. De Bellevue with the law firm of Medlenka & Bruner; Minas L. Gordy; L.O. Peckot; and W.C. Baker of Franklin. The defense attorneys were Phillip S. Pugh and Percy T. Ogden from the law firm of Taylor & Varnado. Nineteen-year-old Dora Murff entered the courtroom smiling and accompanied by her fourteen-year-old brother, Allie, and stepfather, James Duvall. It was reported that Dora wore a tailor-made gray gown with a single red rose pinned to her breast and a large black hat pulled down covering her fawn-colored eyes.

Once the court got underway, an infant's laugh and a wave of its tiny hand in recognition of its aunt Dora temporarily interrupted the proceedings. The

infant was in the hands of Dora's married sister, Mrs. Higginbotham, who occupied a seat in the gallery. The opening of the litigation showed every indication that it would prove to be "spirited and acrimonious" as well as a notable trial of historic proportion for Acadia Parish. There was an array of brilliant legal talent on both sides. The long and bitter proceedings moved slowly. The witnesses were examined and cross-examined for hours at a time, with the attorneys wrangling over motions, countermotions and exceptions.

The dullness of the proceedings was interrupted by the presentation of a large and gorgeous bouquet of roses for Dora. The flowers were sent to her by Mrs. John C. Copes, apparently a friend or family member. Deputy Cassidy made a grand entrance into the packed courtroom sporting a broad smile as he cradled the bouquet in his arms as if he was carrying an infant. He presented the bouquet to Dora as if she were the queen of Sheba. Spectators in the packed courtroom oohed and aahed. The bouquet was composed of red, white and yellow roses along with cape jasmines and ferns. "It seemed to be a source of pleasure and comfort to the young lady," said one witness. James Duvall and Buddie also seemed to enjoy the fragrance and beauty of the flowers.

Just as things began to get started again, there was yet another delay when Duvall had a nervous stomach and felt sick. The court took a brief recess. Once the trial finally got underway again, Dora insisted that she had shot and killed John Miller Delhaye when he tried to run from her. The evidence, however, didn't support her statement. Instead, it all pointed to James Duvall being the triggerman. The prosecution said that James Duvall was the shooter and had two witnesses. It was said that he had fired the shotgun and blasted Delhaye as he ran from Dora. The jury didn't believe that the beautiful Dora could have pulled the trigger either. However, despite eyewitness reports and Dora Murff's incriminating statement, the jury felt that she was a willing coconspirator. All the while, James Duvall pled innocent of all the charges. Could there possibly be another shooter? Could the fourteen-year-old be the triggerman, or could this be a bold conspiracy perpetrated by the defendants? Many of the witnesses thought the defendants would not be convicted.

On December 2, 1913, after deliberating for less than an hour, the verdict was decided at about 4:00 a.m. after one of Judge William Campbell's all-night sessions. When the verdict was read, you could have heard a pin drop inside the courtroom. Allie, the fourteen-year-old stepson of James Duvall, had been present in the surrey at the time of the shooting, but according to statements, he did not take part in the shooting or the argument. Allie was

acquitted of all charges. James Duvall wasn't as fortunate; the jury convicted him of murdering John Miller Delhaye and subsequently sentenced him to ninety-nine years at hard labor in the state penitentiary. Dora was also found guilty and convicted of manslaughter. However, she was sentenced to only four years. When the verdict was read, Dora broke down in tears. Duvall and his wife paled and trembled as the fatal words were read. Allie was scared, and he showed it. Many of the townspeople felt Dora might never see the inside of prison. Sometime after sentencing, Judge Campbell stated that he hoped God would be more merciful with her than he was. With the evidence in the case coupled with the recommendation from the jury, he said that he was as lenient as possible.

The defense attorneys entered forty-two bills of exceptions, saying they would appeal the district court's decision handed down by the trial judge on the grounds that after the jury was impaneled, one of the jurors declared that he would not convict anyone in a case such as this one. He was removed and a new juror sworn in. Judge Campbell refused to grant another trial. On Saturday afternoon, March 23, 1914, arguments on the appeal of a new trial for Dora Murff and James Duvall began before the Louisiana Supreme Court in New Orleans. Another hearing was granted two days later for Dora. After receiving the news, she seemed extremely pleased, almost giddy with the announcement. Louisiana's high court denied a new trial for James Duvall. District attorney Cassius B. De Bellevue had no comments following the announcements.

On Monday, July 3, 1914, Justice Alfred D. Land of the Louisiana Supreme Court acknowledged the fact pertaining to the validity of one juror from the trial in Crowley. However, the justice concluded that Dora would indeed serve time for her part in the murder of John Miller Delhaye. The July 4, 1914 *Crowley Signal* reported that one of its reporters was granted an interview with Dora. He stated that Dora's mother was a recent visitor, and both had greeted the reporter very cordially. Mrs. Duvall said she was very pleased with the fairness of the newspaper reports. Meanwhile, Dora's defense attorney, "Judge" Pugh, said he was prepared to take his case to the highest court of the land—the U.S. Supreme Court.

On July 11, 1914, it was reported that Louisiana Supreme Court justice Frank A. Monroe granted a writ of error to the U.S. Supreme Court in the case of the *State of Louisiana v. Dora Murff and James Duvall*. Defense attorney Percy T. Ogden said it might be several months before the case would be brought before the high court but felt that the granting of the writ of error was significant. Meanwhile, the two defendants languished inside their jail

cells. While awaiting transfer to prison, one of James Duvall's cellmates in Crowley was the notorious Dr. W.C. Woods, an infamous criminal serving two and a half years for abduction. On Monday, July 13, 1914, while the guard was away, Woods used a saw that mysteriously found its way into his hands to cut the lock off his cell door. Duvall declined to take part in the flight. Woods had an accomplice, Alfred LeDoux, who was serving time for minor offenses. According to the *Crowley Signal* of July 18, 1914, "their daring and sensational escape" was quick. They tasted freedom, albeit a short-lived one. The two escapees were found sawing logs. Not literally—figuratively. They were snoring loudly in the woods one mile from Basil, Louisiana, in Evangeline Parish. They had to be roused from their deep slumber. They gave no resistance to Sheriff Fontenot and Deputies Darbonne, Lyman Clarke and Joe Amy.

On October 7, 1914, Dora Murff's attorney said that Dora had been confined to the Acadia Parish Jail and was now in poor health and refusing to eat. She was treated for "hysteria and other ailments." Muff and Duvall were transported to the Calcasieu Parish Jail, where it was reported she had not eaten in three days. Meanwhile, Dora's defense attorneys filed a motion in the Louisiana Supreme Court praying for the court to grant Dora bond, stating that she was charged with manslaughter, which is a bailable offense under state law. Chief Justice Frank A. Monroe signed an order commanding the district attorney of the Eighteenth Louisiana District and Louisiana's attorney general, Ruffin G. Pleasant, to show cause by October 19, 1914, as to why Dora Murff should not be permitted bail.

The request was finally granted, and after making bail, Dora was released after serving nearly one year of her original four-year sentence. James Duvall reportedly served his time in the state penitentiary, enjoying frequent visits from his family. In 1917, his request for pardon was turned down twice by the state board of pardons. By this time, Judge William Campbell, the trial judge who ruled against him, sat with the parole board.

THE BELLE ISLE TRAGEDY

In 1819, while in search of oak and red cedar trees for the construction of warships for the U.S. Navy, James Leander Cathcart and James Hutton surveyed Belle Isle, which is in marshland overlooking the Gulf of Mexico fourteen miles south of Calumet in St. Mary Parish. Cathcart kept a journal and described the island as a beautiful 240 acres of untamed jungle with an abundance of majestic live oaks, countless tropical plants and game birds of every description. The mysterious island also had its share of animals—bears, raccoons and just about every other species of animal. Legend has it that Jean Lafitte used Belle Isle as a base for his smuggling operations. It was once the home of Dr. Walter Brashear, the namesake of Brashear City, which was changed later to Morgan City. The original owner of Belle Isle was Dubuche Benoit de St. Clair, who received it as a Spanish land grant in 1784.

In 1968, the *St. Mary and Franklin Banner-Tribune* wrote an interesting article about an eighty-nine-year-old former resident of Belle Isle. The elderly gentleman was Easton Charpentier Sr., born in 1879 at Bayou Sale. He and his family moved to Belle Isle when he was four years old and remained on the island until he was fifteen. His memories of Belle Isle are very pleasant ones. A grove of pecan trees stood on the island, with several in his parents' front yard. When he and his family arrived on the tiny isle, there was only one family living there and only one house. Over the years, nine other families moved to the island. The Whites, Renos, Kelloggs, Bushinells, Falgouts, Greens and Chaisons once lived there. According to Charpentier's

article, the families paid an agent thirty dollars a year to live on Belle Isle, where they farmed and raised hogs and chickens and grew vegetables. They sold eggs for five cents a dozen in Morgan City, traveling to and from town in a skiff. The men and boys fished, hunted and generally made a good living. Charpentier looked back and remembered Belle Isle as a beautiful and peaceful spot in the late 1800s. He still had hopes that one day he might see the island as it once was.

Belle Isle is a salt dome that protrudes eighty feet above sea level in an area slightly more than half a square mile. It is only accessed by water or air. It is one of 128 salt domes in Louisiana, and it is one of the 5 most famous. The others are Jefferson Island, Avery Island, Weeks Island and Cote Blanche Island. These 5 salt domes are perched in Iberia and St. Mary Parishes. They create a nearly perfect northwest chain beginning with Belle Isle, the southernmost. The domes protrude high above the surrounding landscape and are landmarks for aircraft flying the friendly skies of south-central Louisiana, says former pilot and Abbeville native Allen LeBlanc. Scientists classify the salt domes as "piercement" domes. Belle Isle is said to be the newest and the deepest salt dome and is the "mother bed of salt" thought to be more or less continuous over the entire area. The weight of the surrounding earth causes the salt to extrude upward through the overlying sediment. Geologists say the salt domes are still pushing upward at a rate of perhaps one foot every one hundred years. If it were possible to remove the earth surrounding the domes, the massive pillars of salt would stand like giant plateaus rising twenty thousand feet or more. A spokesman for Cargill Salt estimated that the Belle Isle salt dome contained enough salt to supply the entire world's needs for centuries.

Cargill, which is now the leading salt marketer in the world, first began its mining operation at Belle Isle in 1962 at a depth of 1,200 feet. Over the years, there have been several fires and catastrophes at Belle Isle. One disaster that continues to trouble former employees and family members of twenty-one victims who perished inside the mine more than a quarter-mile below the earth's surface is the fire of 1968. The deadly event occurred shortly before midnight on March 5, 1968, when a fire began deep inside the mine. It was Louisiana's worst salt mine disaster. At the time, Cargill had no rescue teams, so experienced rescuers were called. Meanwhile, workers at the salt mine assembled 1,200 feet of pipe that was pushed down into the mine and pumped in life-sustaining air. The day after the salt mine tragedy, two teams of rescuers consisting of fourteen volunteers boarded a chartered flight from Madisonville, Kentucky. The DC-3 landed at Patterson Air Field with the

nation's top mine rescuers. They were quickly flown the short distance to Belle Isle by helicopter. By this time, it was nearly midnight—twenty-four hours after the tragic fire began.

Three days after the fire, the *Franklin Banner-Tribune* reported: "Workmen tell stories in the late 1890s when a tunnel collapsed in the old mine. The death toll rumors range from 2 to 200, but Cargill officials say they know of no such incident." I remember hearing the stories too of an unsuccessful attempt to mine salt on Belle Isle that resulted in the death of dozens of miners and their pack mules when they were buried alive in the mine by an avalanche of salt. The bodies of those miners were never recovered. I recently spoke with one of the wives of one of the victims of the mine disaster who said that her deceased husband had told her he found a mule head covered in salt down the mine. So perhaps the legend isn't farfetched.

The fire inside the mine burned for two days. Ed Holeman of Sullivan, Kentucky, and Dilford Holmes of Madisonville, Kentucky, were the first rescuers to volunteer to go down the mine following the disastrous fire. Several attempts were made to go down, but carbon monoxide–laden smoke and obstruction in the shaft prevented it. Finally, in total darkness other than their flashlights, the rescuers descended the shaft. They probably looked like spacemen with their fire-resistant coveralls and oxygen tanks. Equipped with gas masks, they were lowered in a makeshift bucket fashioned on-site from a discarded metallic fan casing. Armed with only a bullhorn, they were forbidden to leave the bucket. They called out to the trapped miners, but there was no response. It took seven trips and more than eighty hours of searching over a three-day period enduring ninety-five-degree temperatures before all twenty-one miners were located. It took an additional two dozen trips over several more days before their bodies were finally taken topside on Tuesday, March 12, 1968—exactly one week after the ordeal began. The victims were brought up in the makeshift bucket three at a time. According to St. Mary Parish coroner Dr. G.P. Musso Jr., twenty of the miners died from carbon monoxide poisoning and one from head trauma, probably from falling debris. Governor John J. McKeithen called the disaster a great sorrow for our state.

Calumet was where the salt mine workers assembled and boarded a boat for Belle Isle, some twelve miles away. Cots, baby playpens and chairs had been set up inside a corrugated warehouse near the pier at the Calumet boat landing for the friends and family members awaiting word of their loved ones' fate. Many had been waiting, worrying, praying and hoping since they were first notified of the tragic fire. About seventy people had

gathered inside the warehouse, and a wife of one of the victims kept pacing back and forth waiting to hear the news of her husband. F. Clayton Tonnemaker, former Green Bay Packer football great and Cargill vice president, had the unfortunate task of informing the victims' families of their fate. The announcement shattered the tension when the families were informed of the deceased. One of the rescuers, possibly trying to console the family members of the deceased, said the victims died a painless death. "It was pandemonium. Family members were sobbing and screaming uncontrollably. It was heartbreaking," said Russell Landry of Kaplan, who two weeks earlier had been a nineteen-year-old maintenance electrician at the mine. He personally experienced several close calls—or narrow escapes as he called them. Landry had been employed more than two years when he quit the salt mine over safety concerns. It was his crew that perished that day in 1968. He had quit his job two weeks to the day before the disaster. "I lost some good friends down there," said Landry, who is seventy-three at the time of this writing. Even though it has been five decades since the salt mine disaster, he gets glassy-eyed when he thinks about the fate of his friends and the possibility of what would have happened if he would have stayed.

I recently spoke with Beverly Gisclair, who was married to Minos Langlinais of Kaplan, one of the twenty-one men who died inside the Belle Isle salt mine. She too talked about the chaos inside the warehouse in Calumet when they were informed about the fate of their loved ones. Beverly had just been released from the hospital from surgery two days earlier when her then-father-in-law drove her to the warehouse in Calumet. Everyone inside the warehouse kept staring at the large door waiting for when a representative would come and tell them anything at all about the trapped miners. When it was announced that all the miners had perished, she and others fainted. They couldn't believe what they had heard. At the time of the tragedy, her three children were eight, seven and just over one year old. Today, they're fifty-eight, fifty-seven and fifty.

Debbie (Holeman) Guess, organizer of salt miner statue. *Courtesy of Debbie Guess.*

At the time of the Belle Isle tragedy, the total workforce was sixty employees, of whom thirty-two were classified as regular underground employees. Some of these worked underground

intermittently, including staff officials who spent some time below. The twenty-one victims of the salt mine fire were all from three parishes in south Louisiana: ten victims were from Vermilion Parish, seven from Iberia Parish and four from St. Mary Parish. Two of the victims were twins, and three were brothers-in-law who had married three sisters from Abbeville. Six of the victims had five years' experience, several had been employed three or four years, and a few had been there for several months. One of the victims had been employed for eight days and had not drawn his first paycheck. The families of six of the miners lived in Abbeville and were said to be related.

Following is a list of the deceased miners: Clifford J. Benoit of Franklin, Michael J. Boudreaux (twenty-one) of Abbeville, Luke Milton Boutte of Jeanerette, Roy P. Byron (forty-five) of Abbeville, John H. Christensen Jr. of Franklin, Louis Roy Frilot of Jeanerette, Paul "J.C." Granger (twenty-five) of Erath, Wilbur O. "Bud" Jenkins (twenty-five) of Abbeville, Minos J. Langlinais Jr. (twenty-nine) of Kaplan, Alcide Olivier of Jeanerette, Dallas A. Olivier of Jeanerette, Arthur J. Olivier Jr. of Jeanerette, Percy Joseph Peltier of New Iberia, Hilton J. Primeaux of New Iberia, Dennis T. Romero (twenty-three) of Erath, Leroy Sanchez of Franklin, Homer Smith of Franklin, Harris J. Touchet and twin Harry J. Touchet (twenty-nine) both of Meaux, Leroy Trahan (twenty-seven) of Abbeville and Chester J. Vice (forty-five) of Abbeville. The funeral for the six related victims was held at St. Mary Magdalen Catholic Church in Abbeville, Louisiana, at 2:00 p.m. on March 13, 1968. All was quiet except for the uncontrollable crying of an unidentified ten-year-old boy. Outside the church, many of the local businesses in town closed for the day out of respect of the dead. Two of the men were in flag-draped caskets and received military honors. The sharp report of rifle fire jarred and startled some from deep thought. A bugler sounded taps, and then it was over.

Although a complete federal safety inspection of Belle Isle had never been made before the tragic incident of March 5, 1968, it had been visited several times by Bureau of Mines representatives at the request of Cargill. The inspections were made on several occasions between 1963 and 1967. The most recent visit was made on August 9, 1967, nearly seven months before the 1968 catastrophe. After the last inspection, it was suggested that Cargill open another shaft to be used as an emergency escape. According to reports, when the accident occurred, Cargill had a plan in place to sink a second shaft approximately nine hundred feet from the only existing shaft entrance at Belle Isle. Although every piece of available evidence was examined in detail during a six-month investigation, neither the cause of fire

Debbie and her husband, Ramah A. Guess Jr., organized the salt mine statue and spoke with victims' family of the Bell Isle tragedy. *Courtesy of Debbie Guess.*

nor the point of origin could be established. According to a final report, the fire may have originated in the lower part of the shaft at or below the mining level. It could have been an electrical problem, or perhaps it was the use of oxyacetylene torch. It is also possible that the cause could have been friction on the conveyor belt. Evidence does not clearly favor any one of the three possibilities. Nevertheless, the Interior Department's Bureau of Mines said the disaster could have been prevented if the mine had a separate escape shaft. The following year, two miners died at Belle Isle, followed by one in 1974 and another in 1975. And on June 8, 1979, five men were killed due to an explosion of methane gas. In 1981, Cargill was fined $45,000 for safety violations when an accident claimed the life of one miner. In 1985, due to structural problems, Cargill Inc. abandoned and purposely flooded the Belle Isle salt mine—sealing the fate of the infamous mine forever. The *Monroe News-Star* of Monday, December 30, 1968, reported on a poll taken by the Associated Press and editors across the state; the Belle Isle salt mine disaster was judged Louisiana's top news-producing story of 1968. The story garnered 360 out of a possible 410 points. Another top-ten news event was the investigation by district attorney Jim Garrison into the assassination of President Kennedy.

Many thanks go to Debbie (Holeman) Guess, who in the spring of 1998 helped to organize a memorial to all the fallen miners of Belle Isle. The memorial is located at the tourist center in Franklin along the eastbound lane of Louisiana Highway 90 near the Franklin exit. Debbie Guess is the daughter of Edward Holeman of Kentucky, the first rescuer to go down the mine at Belle Isle in search of survivors. She was instrumental in obtaining the needed funds for the creation of a bronze statue honoring all the fallen salt miners. Two art professors, Jenny Authement and Mike Howes from Nichols State University, created the larger-than-life sculpture of a salt miner. Arthur Olivier from Grand Mary was selected as the model for the sculpture. He was not only employed at Belle Isle, he also lost a son and two nephews in the ill-fated mine.

Railroad History

The Story of Lafayette Parallel

In 1949, the Southern Pacific Railroad (SP) had the largest payroll in Lafayette Parish. According to the December 31, 1949 *Daily Advertiser*, it was more than twice that of any other industry in the area. Southern Pacific employees represented more than a tenth of the entire Lafayette community of thirty-three thousand. Back then, you could buy men's plaid flannel shirts for $1.97 each at Montgomery Ward's mid-winter sale. Langlinais Cash Grocery had a Friday and Saturday special at its three locations—four- to six-pound picnic hams were 33¢ a pound, and K.C. rib-end pork roast sold for 39¢ a pound. Heymann's was still growing and making plans for a city of one hundred thousand. The Jefferson Theatre was showing *Sands of Iwo Jima*, starring John Wayne. Lafayette's economy was bright. It was a vital railroad hub and terminal, and it was also division headquarters for SP's Texas and Louisiana (T&L) lines. Its main track extended from New Orleans to Green's Bayou, just east of Houston.

The highest-ranking SP company official on the T&L lines was Lafayette Division superintendent E.W. Torian. Torian was a Lafayette native who began his career in June 1923 as a locomotive machinist's helper. He continued working for SP during the summer months while attending Rice Institute in Houston. Torian later attended school in Austin, where he majored in law. He worked various supervisory and managerial positions with the railroad in Houston before returning to Lafayette in 1941. Torian was promoted to assistant superintendent in 1943 and became division superintendent when R.M. Glover retired in June 1948 after forty-four years

of service with the railroad. Torian had seventy employees in the downtown Lafayette superintendent's office, which was a large two-story multifunctional wooden structure called the Brown News. On the bottom floor was a café along with the T&L railroad dispatcher's office, the caller's office and other railroad-related offices. It was located on the west side of the main track, behind and slightly north of the old railroad passenger terminal, which still exists today between Johnston Street and the underpass on Jefferson Street.

According to Joseph "J.C." Moreaux, retired SP conductor and later safety officer, railroad operations were transferred to the West Yard at mile post 146.7 sometime around 1959 or 1960. At about that same time, the dispatchers and timekeepers, along with other support personnel, were relocated to Houston. Also at about that time, some of the old railroad buildings were demolished at the old railyard at mile post 144.6, leaving just the Brown News and freight office. The call boys (crew callers) operated out of the Brown News for some time afterward due to labor contracts that stated that if train, engine or yard crew lived within one mile of the station at Lafayette, the caller could be required to physically go to the employee's home and notify the crew member to report for work. There were few telephones back then. The Brown News and freight office were probably demolished sometime in the 1960s. During that period, Johnston Street extended eastward only as far as Garfield Street due to the railyard. At the turn of the century, according to then-retired (now deceased) judge Kaliste Saloom, Garfield Street was often referred to as the mansion block due to the large two-story homes that lined both sides of the street. Most of these homes were originally owned by wealthy SP officials, and many of the homeowners rented rooms to railroaders.

Mrs. Sampson and Mrs. Ledet (Chip Ledet's grandmother) ran boardinghouses for train and enginemen near the railroad's yard office, which back then was on Chestnut Street, recalls J.C. Moreaux. There was also the Carol Hotel, which was on the corner of East Cypress and Sixth Streets. The only reminder of the Carol Hotel, besides the concrete slab, is an old Schlitz lantern sign that dangles precariously near what was the entrance to the hotel's lounge. Also, back in the day, many of the trainmen spent their layover time in their assigned cabooses. On the opposite side of the main track, across from the old passenger terminal, was a large freight office. Next to the freight office was the railyard, which extended from Seventh Street to Fifteenth Street in McComb Addition.

In 1949, there were a total of 184 roundhouse and mechanical employees in Lafayette. They were led by H.J. Bowyer, the division master

The Brown News was Southern Pacific Railroad's Lafayette Division headquarters for a lot of years. It was located next to the old passenger station in downtown Lafayette. *Courtesy of Lafayette Parish clerk of court Louis J. Perret.*

mechanic. The roundhouse was on the edge of Chestnut Street and was equipped with 16 locomotive stalls and inspection pits. The roundhouse forces serviced some 20 locomotives daily, and there were usually 60 to 125 freight cars in the Lafayette railyard at all times for repairs, with 60 car repairers and helpers to repair them. Claude Broussard was in charge of the powerhouse, which had a steam generator with a capacity of eighty kilovolt-amps that powered the machine shop, car department and local and division offices since its installation in April 1924. In case of emergency, the power plant could furnish power to the Western Union office. Lafayette's SP power plant had long been recognized as one of the cleanest shops on the railroad. There were also two steam compressors along with seven steam and three electric pumps all operating noiselessly in Broussard's powerhouse. Many Lafayette residents remember the loud horn that came from the railyard several times each day.

C.R. Shaw was the division engineer on the T&L lines during their glory days. He supervised more than six hundred section men, bridge and building employees, signalmen, bridge tenders and crossing flagmen. They inspected, repaired and maintained 893 miles of main and branch lines, sidings and yard tracks with countless bridges, trestles and station buildings. In 1959, due to the need for expansion, the railroad moved the railyard from

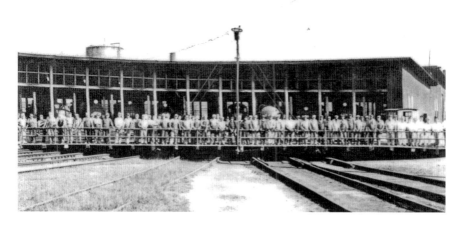

Top: SP railroad's second roundhouse in Lafayette, with sixteen locomotive stalls and inspection pits. *Courtesy of Lafayette Parish clerk of court Louis J. Perret.*

Bottom: The famed locomotive *Sabine* pulled the first train to Lafayette in 1880. It is being dismantled for scrap iron in 1943 for the war effort. *Courtesy of Lafayette Parish clerk of court Louis J. Perret.*

downtown Lafayette to its current location between University Avenue and Pecan Grove Road. Today, there are numerous big corporations in Lafayette, but the first nationwide corporations in America were the railroads, and Southern Pacific greatly helped to lay the economic base upon which present Lafayette thrives.

LAFAYETTE SERIAL KILLER

O ne of the most vile and heartless serial killers who ever walked the face of the earth lived in Lafayette, Louisiana. The year was 1911, and the city's population was less than 7,000. Today, it is somewhere in the 130,000 range. Back then, the biggest complaint before the killings was the dust from the dirt streets, with the pigs and goats that roamed freely a close second. The term "serial killer" hadn't yet been created. That was still several decades into the future. The gruesome killings began in Rayne, about twenty miles west of Lafayette, on a cold dark night in early January. The gruesome murders then moved to Crowley, Lake Charles, Lafayette, Beaumont, San Antonio and Giddens, Texas. The victims were mostly black and mixed-race women and children. Blacks were furious. Many purchased shotguns and pistols, and in some areas, they posted all-night vigils. According to the *Lafayette Advertiser* of Tuesday, February 13, 1912, armed guards were posted on nearly every block in Lafayette, especially when it was learned that two attempts had been made on a couple of homes in the same neighborhood between the "powerhouse and the Grove." Upward of 150 well-armed black men met at Good Hope Baptist Church and adopted resolutions to assist the Lafayette police officers, for which they were greatly commended. Despite not getting much media attention outside the affected area, it didn't take long for law enforcement agencies to begin noticing a pattern: nearly all the victims were women and children, they were all black or of mixed race, and they were all killed at night or in the early morning hours in homes near the Southern Pacific railroad. They were also all killed by a single blow to the back of the head with an ax while they slept.

Scene down Lincoln Street (now Jefferson Street) in Lafayette around 1920. *Courtesy of Lafayette Parish clerk of court Louis J. Perret.*

At first, authorities thought they were searching for a Southern Pacific railroad employee. Officers finally got the break they were searching for when a note was found at one of the many crime scenes. The note was actually a Bible quote, which led authorities to believe that the ax-wielding perpetrator was linked to a religious cult. Acadia Parish sheriff Louis Fontenot received a letter from St. Martinville saying the sender knew who the ax murderer was. Meanwhile, former members of the Sacrifice Church of Lafayette came forward and reported hearing many of the same Bible quotes from their pastor, who was subsequently questioned by the police and later released. The quote was from Matthew 7:19: "Every tree that does not bring forth good fruit is hewn down and cast into the fire." The police then questioned Clementine Bernabet, a black woman who happened to be a parishioner at the Sacrifice Church. Imagine the police officers' surprise when the woman suddenly blurted out that she wanted to confess to killing twenty-two people and that her weapon of choice was an ax. Clementine Bernabet's confession of April 1912 is one of the most stunning declarations of guilt. She also said "other families had been marked for death, and would pay the sacrifice."

Clementine Bernabet was born and raised near St. Martinville in southwest Louisiana. In 1909, as a young unmarried woman, Bernabet,

along with her parents and a brother, moved to Lafayette. She told police that while in New Iberia, Louisiana, in the company of two women and two men, she met Joseph Thibodeaux, a forty-five-year-old black man who said he was a "hoodoo" doctor. The black man assured them that he could sell them "candjas" (good luck charms) that would protect the bearers from detection so long as the candjas were in their possession. Bernabet and her friends paid three dollars each for the hoodoo charms. Afterward, they left New Iberia and went to Lafayette to formulate a plan of action since they were protected by the power of hoodoo. The five drew lots to see who would commit their first murder. As fate would have it, Bernabet pulled the short straw. She took a train to her half-sister Pauline's house in Rayne. The home was near the Opelousas, Gulf & Great Northeastern Railroad depot on the east side of town, just north of the current main track.

Bernabet was disguised as a man and secured an ax in a yard near the home of her first victims. She said it was dark, perhaps nine o'clock in the evening, when she noticed a house with lights on inside. Bernabet slowly walked around the home, peeking inside. She noticed that everyone in the well-lit home was asleep. Bernabet meticulously described how she killed the mother (Edna Opelousas) and her four young children (ages four to nine) with an ax—one blow to the back of the head. Afterward, she removed her disguise and boarded an eastbound Southern Pacific train to Lafayette, arriving about midnight. Bernabet informed members of her gang of her night's accomplishments. At that time, they all assumed the hoodoo was working. She and her accomplices watched the developments in the case with great interest. By then, they knew the hoodoo had done its part and they were safe to do as they pleased.

Next, she told how they had killed the Walter J. Byers family in west Crowley. The husband and wife were both officers of the local black church. According to Bernabet's report, she and one of her female accomplices entered the Crowley home through a rear window, while another kept watch outside. It was decided that since Bernabet held the ax in her hand, she would commit the murders. Bernabet struck the man first as he slept. The wife woke, so Bernabet struck her a blow with the butt end of the ax. She then murdered the two small children. Bernabet and her accomplice thought it best to kill the children instead of allowing them to "suffer as orphans." Bernabet said she and her friends didn't talk about other murders until about two weeks later. She remembered it was the day before an election in February 1911. Bernabet knew that all the police officers would be busy "politicking." She and her partners in crime met at a downtown

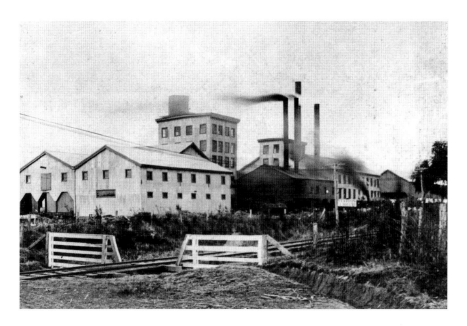

Mouton sugar mill at the end of Oak Avenue (now Jefferson Street), destroyed by fire in 1923. *Courtesy of Lafayette Parish clerk of court Louis J. Perret.*

Lafayette sugar refinery, where they planned who would be their next victim or victims. Bernabet was referring to the Mouton sugar mill at the end of Oak Avenue, now named Jefferson Street. It was destroyed by fire in 1923.

When they reached the railroad where it crossed Vermilion Street, they noticed a light burning in a cabin near Ramagosa's store in the Trahan and Doucet Addition. Bernabet and another woman in her gang entered the house, where again Bernabet wielded the ax. The male victim was Alexandre Andrus, whom Bernabet struck first, followed by his wife, Mimi, two small children who were perhaps three or four years of age and eleven-month-old Agnes, who was in a cradle near the bed. Bernabet admitted that they had overlooked the infant in the cradle until the baby girl woke up and began to cry. She turned around and struck the infant on the forehead, killing it instantly. Before leaving the home, she and her partner placed the man and woman in a kneeling position on the side of the bed. Bernabet admitted that she was near the home the following morning at seven o'clock when the woman's brother, Lezime Felix, came to the house and called. When he didn't receive a reply, Felix looked inside through a window and saw the carnage. The man began crying. Bernabet walked over to him and asked what was wrong. Felix asked her if she would

please notify his parents, who lived nearby. Afterward, Bernabet helped wash the bodies, preparing them for burial.

Lafayette sheriff Louis Lacoste and other officers, including Deputy Coroner L.O. Clark, investigated the gruesome murders. They suspected it was the work of Garcon Godfry, who had escaped from an asylum in Pineville, near Alexandria. However, they later learned from Godfry's mother, who had been arrested, that Godfry was in Maurice, Louisiana, at the time of the murders. Deputy Alphonse Peck and Officer Edwin Campbell went to Maurice and spoke with folks in the community about Godfry's visit, which had been verified. The officers brought Godfry to Lafayette, where he was placed in jail while awaiting his return to the asylum in Pineville. Several other arrests were made relating to the murders, but nothing panned out.

Clementine Bernabet then told how she had murdered the Randall family of Lafayette. It was on Sunday night, November 26, 1911, when she and one of her female gang members gathered some old clothes they carried with them. They "crawled to the house" in Mills Addition, just beyond "the turn on Madison Street in the direction [west] of Couvillon's," where their intended victims resided. J.C. Couvillon's store and residence were located at the corner of Cameron and St. Antoine Streets. Once inside the three-room house, they killed the entire family—Norbert Randall, his wife, their three children and a nephew. Afterward, Bernabet pulled a pistol from under her dress that she had taken from her brother's house earlier in the day. Although Norbert Randall was already dead, she fired the weapon into his chest. Bernabet later returned the weapon to her brother's house. Forensic examination of firearms didn't begin until 1925. The mutilated bodies were discovered by the oldest child of the Randall family, a girl of about ten who had spent the night at her uncle's house. The young girl found the kitchen door open and upon entering saw her parents and the children in bed murdered. Nothing else in the home was disturbed, and like all the other murders, an ax was used; it was found inside the home.

Bernabet returned home at 2:00 a.m. and slept until about 5:00 a.m., when she was awakened by the man she worked for. She was arrested about five hours later by Deputy Peck., whose law enforcement career spanned more than half a century in Lafayette Parish. Bernabet said there had been an agreement made not to tell on one another, but she admitted that she wanted to clear her conscience. She gave the names of her alleged accomplices, and Sheriff Lacoste and his deputies followed up on the individuals, but they all proved to be false. On April 5, 1912, Sheriff Lacoste arrested Joseph Thibodeaux, who sold Bernabet the hoodoo. A week later, on April 13, 1912,

more bodies were added to the growing list of ax murders in Louisiana and Texas.

Five mutilated bodies were found in San Antonio at the home of William Burton. All the victims had been murdered by an ax, which brought the number to forty. And on April 23, 1912, the sheriff also announced that all five of the people implicated in the killing of the Andrus family were now in Lafayette Parish Jail except one— Bernabet's brother Zepherin. The others charged in the gruesome ax murders were King Harris, pastor of the Sacrifice Church; Ute Thomas; Duce and Valena "Irene" Mabry of Sunset; and Mac Thomas. Law enforcement agencies in the area also began receiving anonymous letters from various parts of the country confessing that the writers were the ax murderer.

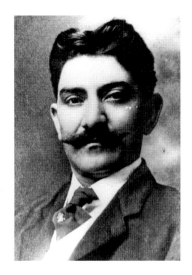

Louis Lacoste, Lafayette Parish sheriff (1904–16). *Courtesy of Lafayette Parish clerk of court Louis J. Perret.*

While awaiting her date in court, Bernabet told her story in detail to R.H. Broussard, a *New Orleans Item* reporter who later published her confession. The accused killer was put on trial for the gruesome murders of twenty-two people. According to published reports at that time, no other case in history attributed more crimes to an individual than this one. The trial was held in Lafayette on October 25, 1912, with Judge William Campbell presiding. It lasted all day Thursday and went long into the night (Judge Campbell was notorious for his all-night court sessions). Judge Campbell had a long, distinguished career. He began as a lawman and then served as sheriff of Lafayette Parish. From there, he enrolled at Tulane Law School, earned a degree and returned to Lafayette to practice law. Campbell became district attorney in Lafayette and then became judge. He was also the second mayor of Lafayette.

Lafayette District Attorney J.J. Robira received an official report from state chemist Abraham Louis Metz giving the result that the blood and brain matter that had been splattered in the room, on the bedding material and on the clothing belonging to Clementine Bernabet was from the same person. Clementine had testified against her father, Raymond Bernabet, who was behind bars charged for the gruesome murder of the Andrus family in February 1911. Clementine's brother, Zepherin, had also been arrested on

suspicion of murder by Lafayette police chief Albert E. Chargois. Chargois was first elected chief of police in 1905 after working for Southern Pacific railroad. He retired in 1955 at seventy-five.

Raymond and Zepherin Bernabet were both cleared of the charges against them. Clementine Bernabet had falsely implicated them in her murderous spree. At 9:00 a.m. on October 26, 1912, the verdict was rendered, and Clementine Bernabet seemed unconcerned and displayed no emotion whatsoever. She was found guilty of the senseless murders of twenty-two innocent people and was sentenced to spend the rest of her life behind bars at Angola State Penitentiary. What's strange is that even though Clementine Bernabet was locked away, the killings continued for a time. A total of forty-nine murders occurred in virtually the same manner—one blow with an ax to the back of the head while the victims slept. No one was ever charged for the other murders, and they remain unsolved.

Several years ago, I visited the archives in Baton Rouge, where all of Louisiana's criminal records are stored. I read in Bernabet's Angola prison records that at one point during her life sentence, she was loaned out to cane farmers during sugarcane harvest season. Well, she did have lots of experience swinging a blade.

Cajun Music and Pointe Noir

Traditional Cajun music is filled with intriguing tales and love stories. Many songs tell of tragedies, despair and broken hearts. One such song is about the tragic love affair of Adam "T-Dom" Hanks and Alice Royer. But first a little about Pierre Varmon Daigle, the person who wrote their story in *Tears, Love and Laughter*. Varmon was a French-speaking Acadian from Pointe Noir, near Church Point, Louisiana. He was a child of the Great Depression. Varmon's mother died when he was only three months old, and then his father abandoned him. Fortunately, Varmon had loving grandparents whom he admired and spoke of often. His elderly grandfather had no education whatsoever, but he was far from ignorant. Over the years, Varmon would often say, "God bless the illiterate man that gave me an education." He explained that his grandparents, Polish Daigle and the former Carolyn Doucet, had done without to make certain Varmon had a good education. The first thing Polish did was buy his grandson a dictionary. Varmon didn't disappoint his grandparents, nor did he waste their time or money. He never forgot what his grandparents did for him. Varmon applied himself and studied hard. He had known from an early age that the key to success was an education, which still holds true today.

Varmon taught numerous people how to read and write and do math. Family members say that when Varmon returned home from teaching school, he led adult education classes well into the night several times each week. He began with his wife's siblings, who had never had a chance to go to school. It was his way of paying back for his education. Besides being

Pierre Varmon Daigle (1923–2001) wore many hats: World War II and Korean War veteran, educator, composer, playwright, storyteller, record producer, photographer and many more. *Courtesy of Brenda Daigle Briggs.*

an educator, Varmon was a veteran of the Second World War and the Korean War. He was also a journalist, photographer, composer, playwright, author, storyteller, gardener and my fifth-grade teacher at South Rayne Elementary School many years ago. Varmon was passionate about preserving Cajun culture, particularly Cajun music. Even though he couldn't play any musical instruments, he helped countless musicians.

Over the years, Varmon collected wise old Cajun French proverbs or interesting sayings from Monsieur Bov Daigle, who owned a small grocery store in Church Point. Little did Varmon know back then that he would use those old French sayings in songs he wrote. An excellent example is "La Valse de la vie" ("Waltz of Life"), one of Varmon's first songs for the fabulous group Cajun Gold, co-led by Paul Daigle and Robert Elkins—two of the very best Cajun musicians. Varmon not only composed the lyrics, he also wrote the arrangement and made certain it was played exactly to his satisfaction. Varmon was great at hearing a story and recreating it in a brilliant musical composition. Another good example of this is in his 1989 Cajun French Music Association award-winning song "*La Lumiere dans ton chassis*" ("The Light in Your Window").

It was probably sometime in the early 1970s when Varmon interviewed numerous people who personally knew T-Dom Hanks and Alice Royer. Their love story took place in the early 1900s in the hamlet of Marais Bouleur, located in the general vicinity of Mire in northeastern Acadia Parish. T-Dom and Alice were young and madly in love, but as in many love stories, Alice's parents didn't approve of her beau. They didn't think he would make a good husband or son-in-law. T-Dom was wild and happy-go-lucky. He loved to ride his horse Gros Henri while drinking from a jug of whiskey with his hat cocked to one side, indicating he didn't have a care in the world. Times were very different back then—the couple respected Alice's parents' wishes and broke off the engagement. Alice soon married Edmund Miller, while T-Dom continued riding and drinking. The heartbreaking story of T-Dom

Cajun Gold is one of the greatest Cajun bands in Acadiana. Music was composed and written by Pierre Varmon Daigle, who couldn't play any instruments but wrote great lyrics. He also directed the musicians on how his music was going to be played—his way or no way. He was truly a Renaissance man taken from this world far too soon. *Courtesy of Brenda Daigle Briggs.*

and Alice spread throughout Acadiana, and one day, a beautiful waltz was created. Time didn't mend T-Dom's broken heart. He was still very much in love with Alice.

Finally, T-Dom relented and married Armena Thibodeaux, and together they raised seven children. Despite being married, whenever T-Dom went to house dances, he would pick up the accordion and sing and play *"La Valse a T-Dom Hanks"* as tears rolled down his cheeks. Legendary accordionist Angelais Lejeune, the uncle of the famous Iry Lejeune, was given permission by T-Dom to use the lyrics when he recorded his version of the waltz. Angelais informed Varmon that once, while playing a dance in Duson, a woman approached him and requested *"La Valse a T-Dom Hanks."* Angelais complied and said that the entire time he played, the woman stood nearby and solemnly listened. When the waltz ended, she thanked him and slowly walked away. Angelais said the woman was Alice,

and she seemed to be deeply moved by the song. As with most tales, it continued to grow until it became legend.

T-Dom Hanks was born on September 23, 1885. Many years later, when he was on his deathbed, several members of his family thought Alice would certainly visit him, but she never did. He died on June 6, 1959, at the age of seventy-four. Some say he died of a broken heart. Sometime later, Varmon Daigle met one of T-Dom's daughters in Crowley. She said that her father had told his children the sad story. She not only provided Varmon with a picture of the lovers but also informed him where he could find Alice in the Judice community. Varmon asked, "How often does one meet a legend in a lifetime? Alice was a gentle woman with pale blue eyes and a quick smile. There were still hints of the past beauty that had broken T-Dom's heart." Alice Royer was born on September 1, 1892. She was eighty years old when Varmon interviewed her in 1972. T-Dom Hanks and Alice Royer were talked about for decades. Folks remembered seeing T-Dom riding Gros Henri through the gently swaying prairie grass. "The story was well known in the Prairie Hayes community," said Dr. C. Ray Brassieur, assistant professor of anthropology at the University of Louisiana at Lafayette (UL). Brassieur's grandmother personally knew T-Dom, Alice Royer and their parents. Hopefully, the star-crossed lovers' story and many others will be preserved and not die. World-famous Cajun fiddler Michael Doucet was quoted as saying, "Happily for me and for everybody else, the music has blossomed. It just refuses to die. It is the resilient music of a resilient people." Unfortunately, Pierre Varmon Daigle died in May 2001, just six months shy of turning seventy-eight—way too soon, for he still had plenty he wanted to accomplish.

Lawrence Walker, a great Cajun musician who is now deceased, recorded *"La Valse a T-Dom Hanks"* under the title *"Chere Alice,"* which is still an all-time favorite waltz. In his day, Walker was every young accordion player's idol. One of those early musicians was Doreston "Doris" Matte from Pointe Noir, the same area where Varmon Daigle once lived. The area has produced more Cajun musicians per capita than anywhere else. It's known as the birthplace of Cajun music. Family members say when Doris Matte first set eyes on legendary Lawrence Walker and saw the crowd reaction as the great musician played wearing his trademark white shirt and black tie, he knew at that very moment he wanted to play the accordion. Doris wanted to be a crowd pleaser like his idol. Walker was a trendsetter and a strict disciplinarian when it came to his music. You had to play on time every time or you weren't playing with Walker.

Doreston "Doris" Matte (1937–2011), famed accordionist from Pointe Noir, was inducted into the Cajun French Music Hall of Fame in 2009. *Courtesy of Pat Daigle.*

According to an interview with the late Selise Daigle and her son Patrick, Doris first began playing dance halls in 1958 with the Lake Charles Ramblers, making ten to fifteen dollars a night. He played traditional Cajun music on a Sidney Brown instrument, the first Louisiana accordion maker. Doris was like his idol—he wrote and recorded only original songs. His first and top recording was "*Les Traces de mon boghei*" ("Tracks of my buggy"). It's in every Cajun musician's repertoire, and it can still be heard any night of the week in any number of dance halls throughout Acadiana. People who knew Doris said that after the release of his first record, he was the hottest thing on the market.

Doris began recording on the heels of a music surge known as the Cajun music renaissance. It all began after our military returned home from the Second World War. According to now-retired UL professor Barry Ancelet, "They wanted to hear the music they grew up hearing—before the accordion was pushed aside and no longer featured on recordings." Many historians credit Iry Lejeune (who was also from the mysterious community of Pointe Noir) for the rebirth after his recording of "*Love Bridge Waltz*." And fortunately for us, disc jockey Eddie Shuler from KPLC in Lake Charles featured Iry on several broadcasts, which greatly helped to launch the renaissance.

Unfortunately, the unthinkable happened in 1964: Doris's three-month-old daughter died from a heart defect. He and his wife were devastated. Shortly thereafter, at the height of his popularity and at the top of his profession, Doris quit playing music. In 2009, Doris Matte was inducted into the Cajun French Music Hall of Fame in Eunice, Louisiana. His fans were saddened when they learned of his passing on Monday, October 10, 2011, at the age of seventy-four.

JEFFERSON COUNTY LINE

O n Tuesday, August 31, 1926, the body of Auguste "Nago" Thibodeaux was lowered into his final resting place at Magnolia Cemetery in Beaumont, Texas. He was survived by his wife, Odelia, and their twelve children. While the family grieved at the graveside and before Nago's grave was filled with dirt, Auguste's sons Albert and Elton Thibodeaux, ages fourteen and thirteen respectively, were led away in chains by the law. The family was devastated when the young boys were placed in a waiting police car and taken to jail in Liberty, Texas. The boys were charged with stealing cattle, which was the cause of their father's death. Odelia and the children had just experienced the tragic loss of Auguste, and now they were facing another heart-breaking episode.

Auguste and his family were sharecroppers for the Terrell-Combest farm near Double Gum Island in Jefferson County, Texas. They barely eked out a living on property adjacent to the border of three counties—Chambers, Liberty and Jefferson. The Thibodeaux family had moved there from Pointe Noir, in the northern part of Acadia Parish, after Auguste was released from a prison sentence for derailing a train. He had an accomplice—his older brother Octave. After the Southern Pacific Railroad refused to reimburse Octave for a cow that was struck and killed by a train, the brothers decided to get even. According to the *Crowley Signal* of November 24, 1894, that fateful day was November 16, 1894. The brothers broke a railroad switch lock south of Bayou Mallet, which was four and one-half miles south of Eunice on Southern Pacific's Midland Branch. They then lined the switch

points halfway between the two railroad turnouts, and for good measure, they wedged the points open so they wouldn't return to their normal position.

An evening train left Crowley on schedule for the Midland Branch carrying its ordinary freight and two or three passengers. When the train reached Bayou Mallet, it had been dark for an hour or more, which prevented the engine crew from seeing the misaligned switch points. The locomotive and an undetermined number of railcars derailed, which caused the death of one and multiple injuries along with substantial damages to railroad property. The *Crowley Signal* of the same date as above reported that William Jackson, a brakeman from the derailed train, ran to Eunice in thirty-two minutes to get help. Dr. H.S. Joseph was sent to the derailment on a railroad handcar, but when he got there, fireman Hugh Geiger "had breathed his last." The fireman had been badly scalded from steam. Locomotive engineer Joseph Mauldin had multiple injuries.

Octave and Auguste were quickly arrested and taken to the Acadia Parish jail to await trial. Meanwhile, in Crowley, a double trapdoor gallows was constructed in anticipation of a guilty verdict. On Friday, March 28, 1895, after deliberating for less than three hours, the jury found the brothers guilty. Auguste was charged with manslaughter and sentenced to fourteen years of hard labor at Angola. Octave was found guilty of murder and sentenced to be hanged "on such a day as may be named by the governor." Judge William Charles Perrault Sr. overruled the Thibodeauxs' request for a new trial but did grant them appeals to the Louisiana Supreme Court. Some folks regarded Octave as a kind of Robin Hood. Remember the epic American outlaw heroes Frank and Jesse James, the Cole Younger gang and Billy the Kid? The one thing they had in common—besides being outlaws—was the fact that newspapermen like John Edwards of Kansas wrote tantalizing articles about them in what were called yellow-backed or dime novels. Some say Octave was very much like Billy the Kid.

On December 1, 1895, nine months after their court date, Octave somehow managed to escape from the parish jail. He stole a horse and made his way down to Cameron Parish along the Gulf Coast. Octave had plans to board a boat at Leesville (Cameron) for Mexico. Octave traded the horse for a gun, ammunition and a small amount of cash. Instead of leaving, Octave met a friend outside of town, where a lawman came up and arrested him. The friend convinced the lawman that he was mistaken, and the lawman said he would go see Sheriff Elridge W. Lyons. The sheriff had tracked Octave to the Gulf Coast. Instead of taking a boat to Mexico, he did like Billy the Kid and headed back to familiar territory.

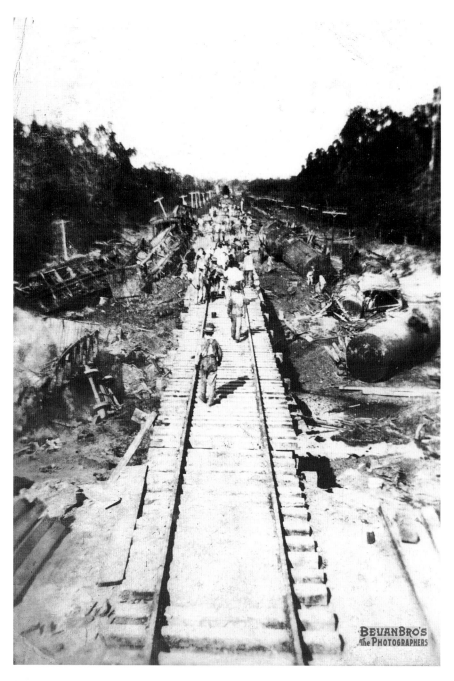

SP Midland Branch derailment scene, 1894. *Courtesy of Bevan Bros. Photography.*

Octave stayed with a friend and relative, Clemile Jaunice, in the area of Coulee Croche (Cankton) in St. Landry Parish for about a week. He was planning to leave the following night to catch a boat on the Atchafalaya River for Mexico when he spotted a large posse of lawmen approaching the home. Octave went out back into an open field, taking his Winchester rifle with him. He didn't want any shooting taking place in the home, since there were children there. The lawmen were hesitant to approach Octave and stayed out of rifle range. After a long standoff, Octave stuck his rifle in the ground and placed his hat over the end of the barrel, waving his hand for them to come closer. When Deputy Sheriff P.D. Williams of St. Landry Parish got closer, Octave said he'd surrender "if the deputy would pay me for my rifle, which he did, giving me $16 and I got the money before they got the gun." Octave gave the money to the Jaunice family. The date was Thursday, February 8, 1896.

Octave had been on the run for about two months before he was captured and returned to Acadia Parish jail. While Octave was waiting to be sent to Angola, a representative of the local newspaper, the *Crowley Signal*, interviewed him in his jail cell. Octave was asked how he had managed to escape from jail. He took great pleasure in describing the events. He also told the interviewer about selling his rifle to the sheriff before surrendering and giving the money to the Jaunices. When the interview was over, like outlaws of the Old West, Octave made certain the reporter had the correct spelling of his name. He was quick to point out an error in an earlier article. And as luck would have it, the Louisiana Supreme Court overturned the Thibodeaux brothers' conviction. They were given less severe charges and sentenced to five years of hard labor. On October 25, 1898, at the age of thirty-five, Octave Thibodeaux died of pneumonia in Angola. Auguste served his time and then moved his family near the small farming community of Double Gum Island, west of Beaumont, Texas. Old habits die hard. After moving to Texas, Auguste supplemented his livelihood by occasionally taking a cow or two. It was something he and Octave regularly participated in while at Pointe Noir before becoming residents of Angola.

Sometime in August 1926, local cattle ranchers began to notice their herds were dwindling. They decided to hire Graves "Frank" Peeler—their version of Tom Horn. Peeler was a Texas Ranger and special agent for the Texas Cattle Raisers Association. He was brought to the area of Double Gum Island for one reason only—to stop the cattle rustling. Peeler was hired by Frank Y. Drew of Drew Brothers Ranch. On August 30, 1926, Peeler

said he was hiding in thick shrubbery near Auguste Thibodeaux's house when he spotted a youth driving cattle in the direction of the Thibodeaux home. He said he believed the cows were the property of Guy Freeman, a cattleman in the vicinity. A short time later, Peeler heard six gunshots and saw a cow lying on the ground with two boys preparing to butcher it. He said he covered the boys with his gun and ordered them to call their father, whom he believed to be hiding nearby. The elder Thibodeaux appeared from a cotton field with a rifle. According to the ranger's testimony, Auguste Thibodeaux not only disregarded the lawman's instructions to surrender, he also fired at the Texas Ranger. The bullet pierced the lawman's left ear. Peeler said he returned fire, emptying his 30-30 Winchester, and then he walked to where Auguste was shot.

The ranger said, "I noticed that the gunman continued to stir in the grass, so I fired another shot into Thibodeaux's body." Peeler said afterward he drove to Devers, where Dr. Carr dressed his wound. News of the shooting reached Beaumont at 2:00 a.m. on Tuesday, August 31, 1926. An ambulance from the Pipkin & Brullo Funeral Parlor, along with Justice of the Peace R.A. McReynolds, was dispatched to pick up the body. The two young Thibodeaux boys were questioned by Justice McReynolds. The boys said they were near their father when the shooting occurred. Albert, the fourteen-year-old, testified to hearing a gunshot and seeing his father fall. Elton, the thirteen-year-old, said he saw the man who fired the shot but didn't recognize him. The two boys said they hurried home and told their mother what had happened. The boys' mother sent them to Beaumont to retrieve their brother Ellis. All three of them quickly returned home. Peeler, the Texas Ranger, told his version of the story to Deputy Sheriff Allan Wheat. Peeler said he had been called by cattle owners in the vicinity of Liberty to investigate the disappearance of cattle.

Justice McReynolds returned to Beaumont later that morning and stated that Thibodeaux had four bullet wounds to his body. He said the wound that caused death had been inflicted by a shotgun blast, which made a hole as large as a man's fist directly over the heart. McReynolds said the other wounds were either made with a Winchester rifle or a very heavy-caliber pistol. The undertaker corrected McReynolds and said there were actually six gunshot wounds to Thibodeaux's body, one of which appeared to have been made by a shotgun blast due to its larger diameter and ruggedness. The other wounds were apparently caused by a rifle or pistol, said the undertaker. After hearing from everyone involved, Sheriff L.H. Hightower of Liberty County filed charges of murder against Frank Peeler. The ranger was

subsequently placed under arrest, although he was soon released to Frank Y. Drew of the cattlemen's association.

At four o'clock on Tuesday afternoon, August 31, 1926, Father O'Conner of Sour Lake Catholic Church conducted the funeral service at the Pipkin & Brullo Funeral Parlor in Beaumont. Auguste Thibodeaux's body was then taken to Magnolia Cemetery for interment. Out of respect for the Thibodeaux family, Sheriff Hightower had the deputies wait until Thibodeaux's body was in the ground before arresting Albert and Elton. The two boys pled guilty to charges of stealing cattle. A jury assessed punishment of four years in the Texas State Penitentiary. The boys' aging mother and family members were overwhelmed with grief. But then the jury foreman placed their hearts at ease when he recommended that the boys' sentence be suspended and the judge agreed. The boys were placed on probation and ordered to pay a fine.

On October 13, 1926, Peeler went before a judge at the Liberty County Courthouse and pled not guilty for the murder of Auguste "Nago" Thibodeaux. Auguste Thibodeaux's family thought that Peeler had used excessive force when he emptied his 30-30 rifle and then grabbed a shotgun to finish the job, but the jury sided with Peeler, who was cleared of all charges. The gallows that had been built in Crowley for Octave and Auguste Thibodeaux shortly after their capture had been dismantled and stored away, never having been used. On April 2, 1897, it was loaned to Lafayette Parish and used for the execution of two Frenchmen, Ernest and Alexis Blanc. The two brothers had savagely tortured and killed Martin Begnaud, the proprietor of a general store in Scott.

Shootout at the Railyard

T he city of Lafayette is the fourth-largest in Louisiana behind New Orleans, Baton Rouge and Shreveport. It has a population of 127,657 according to a 2015 report. Lafayette is the seat of Lafayette Parish in the heart of Cajun country, 144 miles west of Algiers, where the NOO&GW began building its railroad westward in the mid-1800s. In 1926, when this story began to unfold, Lafayette was much different. It had a population of about 12,000, mostly French of Acadian (Cajun) descent, and was headquarters for Southern Pacific railroad's Lafayette Division. The Southern Pacific was Lafayette's largest employer—more than twice that of any other industry in the area.

Here are a few noteworthy items from 1926: Prohibition was alive and well; Henry Ford implemented a forty-hour week for his factory workers; U.S. Route 66, which runs from Chicago to Los Angeles, was completed; and it was the year that Marilyn Monroe and Fidel Castro were born. It was also the year of the shootout in the SP railyard at Lafayette. Back then, there was no West Yard in Lafayette. SP's railyard was in the downtown business district, across the railroad track from the old passenger depot. Today, the old historic passenger depot is part of Lafayette's transportation center, hosting Amtrak, city taxicabs and the city bus terminal. Due to expansion needs, sometime in the early 1950s, West Yard was built about three miles northwest of the 1926 location. According to the *Lafayette Daily Advertiser*, at approximately one o'clock on Sunday morning, July 11, 1926, railcar inspectors Jules Guidroz and Paul Doucet Jr. were inspecting a freight train

St. John Oak, Lafayette, 1931. *Courtesy of Lafayette Parish clerk of court Louis J. Perret.*

that had entered the Lafayette yard sometime earlier from the Alexandria Branch. The branch line was approximately seventy miles long and ran in a north–south direction from Lafayette toward Alexandria. It was taken up sometime in the 1980s. Guidroz and Doucet were inspecting the freight train when they came upon an age-old problem on the railroad—an open railcar door. As they attempted to close the door on what was supposedly an empty boxcar, the car inspectors heard voices coming from inside. They asked who was there.

Two black men said their names were Sam Woods and John Williams and that they had boarded the freight train in Alexandria and rode it to Lafayette in hopes of finding employment. Also present when questioning the two train riders were railcar inspectors Clement Breaux and August Kilchrist. The inspectors instructed the two non-revenue train riders to follow them to the SP yard office, where someone would assist them. Boudreaux and Kilchrist led the way accompanying Williams and Guidroz. Doucet followed a few steps behind with Woods. As they began walking toward the yard office, Woods reportedly pulled a gun for no apparent reason and began shooting at the car inspectors. The gunman fired three shots from a revolver, which was later described as a .38 special. Guidroz was shot twice, once in

SP training seminar in Lafayette around 1950. *Courtesy of Lafayette Parish clerk of court Louis J. Perret.*

the arm and once in the upper body, which immediately killed him. Doucet took a bullet to the abdomen and died a short time later. After the shooting, Woods and Williams quickly left the area on foot. The incident launched one of the biggest manhunts in Lafayette history. Chief of police A.E. Chargois and Sheriff J.D. Trahan immediately summoned every available police officer to help in the search for the two men. There were volunteers from other areas and from other departments in the city. A great number of citizens also joined in the manhunt. According to the *Lafayette Daily Advertiser*, "There was a net thrown around the city." Law enforcement officers were stationed at strategic points throughout Lafayette, while other officers were sent to nearby towns.

When police officer Simon Chiasson reported to Chief Chargois, the latter asked the officer if he was provided with a good gun. Officer Chiasson stated that he had a shotgun. The chief then suggested that the officer secure a car and driver. Officer Chiasson; Ameliear Fournier, a security guard; and Willie Olivier, a city street department employee, drove to the railyard. The threesome began searching with police officer Leonard Thibodeaux and his son Deputy Sheriff Stanley Thibodeaux. The two groups of lawmen left their vehicles near the Vermilion Street railroad grade crossing in the center of town and searched the railyard for the two wanted men. Another group stayed near the grade crossing in the event that the two wanted men

traveled in that direction. Deputy Thibodeaux was searching in the weeds near the Texas Oil Company when he came upon Woods. The gunman ran while exchanging gunfire with the officer. The two wanted men had split up earlier; Williams hid in an area of weeds and later turned himself in to police. He admitted that his name was actually Mike Williams and claimed he had nothing to do with the shooting.

Meanwhile, Woods entered a vacant building that belonged to SP between East Vermilion Street and the railroad tracks but soon began running again in the railyard. He ran toward a group of law enforcement officers, and Officer Chiasson leveled his shotgun at him and pulled the trigger. His weapon failed to discharge, and Woods fired his handgun, striking Chiasson once in the head. Fournier ran to assist Officer Chiasson. By this time, Percy Yeager, a railroad switchman armed with a shotgun, joined the chase. Woods fled under a freight train in the railyard and headed toward a moving freight train that had entered the Lafayette yard. The switchman cautiously pursued the fugitive on the opposite side. After exchanging a few rounds, Yeager fired once between the drawbars of two railcars, dropping Woods to the ground. The outlaw was quickly taken into custody without further incident.

Woods was first taken to city hall, where Dr. M.M. Mouton, the Lafayette Parish coroner, examined the outlaw. Woods reportedly had a number of buckshot wounds about the face and body. He also had four bullet wounds, though none was life-threatening. Woods had one bullet wound below and one above his right knee. Another bullet was lodged in a thigh and still another one in the middle finger of his left hand. Chief Chargois and Dr. Mouton determined that three of the bullets that hit Woods were from a .44 and one from a .38-caliber pistol. It was decided that the bullet wounds were inflicted by Deputy Sheriff Stanley Thibodeaux with his .44-caliber handgun and his father's .38-caliber revolver. About two hours later, Woods was taken to Franklin in St. Mary Parish, about fifty miles south, partially for safekeeping but mainly because the Lafayette jail and courthouse had been torn down and a new one was in the process of being built. Woods was in custody of Sheriff Trahan, Deputy Sheriffs Jack Doucet and Wilfred Begnaud, police officer Albert Trahan, SP special agent B.F. Purl and Deputy Sheriff Dan Mouton, who drove them in an ambulance that belonged to the Dauterive Company. It was learned that Mike Williams was a nineteen-year-old who gave his address as 2371 Marks Avenue, St. Louis, Missouri. Williams was kept in jail for further questioning. It was later determined that he was not connected in any way with the shooting.

An inquest was held later that morning at nine o'clock conducted by Dr. Mouton at the undertaking parlors of Rene Delhomme, where the bodies of the slain men had been taken. At the time of the inquest, the shooter's name was not known. Members of the inquest were L.H. Frances, L.E. Connolly, A.S. Oge, Ovide LeBlanc and George Antoine. Witnesses were Clement Boudreaux and August Kilchrist, the two car inspectors who had accompanied the two now-deceased car inspectors. The bodies of Officer Chiasson and Jules Guidroz were taken from the Delhomme Undertaking Parlors and brought to their homes, as was customary during that era. The body of Paul Doucet Jr. was taken to his father's home near Scott.

Funeral services for Paul Doucet Jr. were held at 9:00 a.m. on Monday, July 12, 1926, at St. Ann's Catholic Church in Scott. He was a resident of Mouton Addition in Lafayette and was survived by his widow, the former Armontine Hardy of Breaux Bridge, and his parents, five brothers and two sisters, all of Lafayette Parish. Funeral services for Jules Guidroz were held at 2:00 p.m. at St. John's Cathedral in Lafayette. He was a resident of Mudd Addition in Lafayette. He was survived by his widow, the former Hazel Guidry of Lafayette, his mother, four sisters and three brothers, all of Lafayette Parish. Funeral services for the forty-nine-year-old Simon Chiasson were held at 4:30 p.m. at St. John's Cathedral. Officer Chiasson resided on Bienville Street in Scott. He was survived by his widow, the former Lea Breaux of Scott, five daughters, two sons and six grandchildren.

All three men were killed while performing their duties in the early morning hours of July 11, 1926. Hundreds of grief-stricken mourners attended the funerals of all the deceased, who were well-known area residents. Area businesses closed their doors out of respect for the deceased. There were dozens of police officers and railroad men at the funerals. It was standing room only at all three services, and they were well attended by city officials as well as SP officials.

On July 15, 1926, while in custody in the St. Mary Parish Jail, Woods made a voluntary statement saying he denied responsibility for the killing of the three men. He thought that Williams did the shooting. Woods also said that after being shot twice in the leg, he managed to cross a fence and ran to the rear door of a nearby home, where he told the owner that an attempt was made to "kill an innocent man." Woods asked for protection, but the homeowner advised Woods not to enter the home. He then ran around to the front of the house, where he was told to leave. At that time, Woods returned to the railyard. Later it was learned that the home Woods referred to was owned by Edmond Melançon.

On October 9, 1926, sometime shortly before 11:00 a.m., District Attorney James Gremillion learned that the grand jury of the Fifteenth Judicial District Court delivered a true bill of indictment against the nineteen-year-old Woods. Gremillion also learned that the accused murderer was actually Sam Woodard of Wynne, Arkansas. The court case against Sam Woodard began on the morning of Monday, October 18, 1926, led by Gremillion and court-appointed defense attorneys Waldo Dugas and A. Wilmot Dalferes. According to the October 21, 1926 *Lafayette Advertiser*, "Forceful pleas were made by counsel on both sides in arguments that began shortly after 3:00 o'clock Wednesday afternoon." Mike Williams was a witness for the state, while Woodard was the only defense witness. Woodard confessed to killing the two railroad men in self-defense. He stated he became frightened and feared for his safety after he "was struck with a bar or some other object and was temporarily stunned from the blow."

The case was given to the jury at six o'clock Wednesday evening. The jury deliberated for five minutes before returning a guilty verdict. According to published reports, Woodard showed no emotion when the verdict was read. One week after Woodard was found guilty, Judge W.W. Bailey pronounced the sentence of death. Again, Woodard displayed the calm and apparently indifferent attitude that he had shown throughout the court proceedings. When asked by Judge Bailey if he had anything to say, Woodard replied no. He was taken to St. Martinville jail, sixteen miles southeast of Lafayette in St. Martin Parish, to await execution. Louisiana governor O.H. Simpson set Woodard's execution date for Friday, January 27, 1927.

According to the *Lafayette Daily Advertiser*, there were about three thousand spectators gathered around the enclosure at the courthouse square in Lafayette in hopes of getting a chance to see the execution. It was a big event, and people came from miles around. The death warrant was read in Woodard's presence, and then the condemned man was marched up the eighteen steps to the top of the gallows. This was the second time Woodard was read the death warrant—it had been read to him while he was in jail in St. Martinville one month earlier (according to law, the death warrant must be read to the condemned person one month prior to the execution date). Woodard was dressed in a dark suit, white shirt and tan shoes. He maintained the same uninterested attitude displayed throughout the court session. Besides official witnesses, officers and others inside the wooden enclosure, there was one other person— Hazel Guidroz, widow of Jules Guidroz. They were married less than six months at the time of his death.

Sheriff Trahan asked Woodard if he had any last words, to which he replied, "No sir." The sheriff pulled a black mask over Woodard's head and placed the hangman's noose around his neck. Sheriff Trahan paused a moment and then pulled the wooden lever. Sam Woodard was pronounced dead at 1:27 p.m. His body was taken down and placed in an "undertaker's basket." The sheriff had made arrangements beforehand with Father Wrenn and Clifton Mouton, the local black undertaker. Sam Woodard was buried in what was then known as the colored Catholic cemetery in Lafayette.

Sam Woodard's execution had been the first in Lafayette Parish since 1906, when Dave Howard, a black man, confessed to the rape of a twelve-year-old Opelousas girl and as many as nine assaults on women. Howard also confessed to the unrelated ax murder of Joseph L. Breaux, a local merchant in Lafayette. Prior to Howard, there had not been an execution in Lafayette Parish since the double hanging in 1897 of brothers Alexis and Ernest Blanc, two white men from France.

A NOBLE SON

In March 1899, the *New Iberia Enterprise* published a historical essay by Dr. Alfred Duperier in two installments one week apart. At the time, he was said to be the oldest native citizen of New Iberia. He was born in 1826 in what was then known as the Attakapas region and later became part of St. Martin Parish. His family founded New Iberia, and their property was in the center of town. Alfred Duperier was educated in Ann Arbor, Michigan, where he graduated as a physician. After first considering foreign travel, he began his practice in his hometown and became a prominent physician in New Iberia during the mid-to-late 1800s and into the dawn of the twentieth century. During the yellow fever epidemics of 1853 and 1867, Dr. Duperier was entirely devoted to the people of New Iberia, dispensing food as well as medical treatment. Dr. Duperier also assisted in the burial of the dead. He virtually lived in his horse-drawn buggy, especially in 1867. He was remembered for his donation of a large tract of land between Iberia and Julia Streets that became St. Peter's Catholic Church, parsonage and convent. In 1837, when Alfred Duperier was eleven years old, his father, F.H. Duperier, led a movement to create the parish of Iberia from what was once part of St. Martin and St. Mary Parishes. For thirty-one years, pressure was applied to create a new parish, which was finally approved in 1868, but it fell on the shoulders of Alfred Duperier to complete after the death of his father. The documents were drawn to petition the Louisiana legislature for the division of St. Martin Parish. The petition was adopted without a dissenting vote. It was approved and signed by the president of

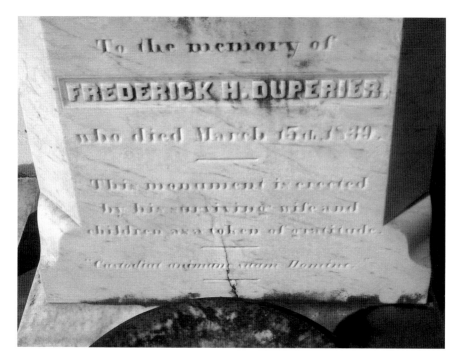

Frederick H. Duperier fought to create Iberia Parish. *Courtesy of William Thibodeaux.*

the senate and its secretary. The newly created parish of Iberia promptly commissioned four police jurymen and a jury president.

New Iberia is prominently situated on Bayou Teche with beautiful moss-covered oaks scattered about. The bayou begins at Port Barre in St. Landry Parish, where it draws water from Bayou Courtableau and flows southward for 125 miles to meet the Atchafalaya River in Patterson. In the mid- and late 1700s, when the Acadians first began to arrive in south Louisiana, Bayou Teche was the primary means of transportation. New Iberia began to assert its commercial importance in the 1840s, especially after the navigational interruption through Plaquemine during low-water stages on the Mississippi. It created a profitable demand for large-capacity gulf steamers. Those steamers were not able to travel above New Iberia, so they landed their large cargoes destined for all points north and west at New Iberia. It became the trade center of a large area, which continued until the completion of the NOO&GW. It also became the distribution center for mail and passenger traffic overland into Texas. New Iberia also controlled a large cattle trade from Texas and the surrounding territory. During this period, New Iberia

assumed commercial supremacy over St. Martinville and Franklin. By 1899, New Iberia was a real deep-water navigational terminal.

Some of Dr. Alfred Duperier's earliest recollections are within Dowd's map, which included the village of New Iberia. At that time, there were twenty-five residences, four stores, one blacksmith shop, one bakery, one tannery and two saloons. The towns of Loreauville, Jeanerette, Burke and Cade were not even thought of yet. And the capital in trade in those early days was probably equal to a million dollars. Local merchants like Shute & Taylor, later Shute and Devalcourt, "did a large wholesale and retail advancing business." They held large cash deposits for men such as J.D. Wilkins and stock raisers who enjoyed their assurance. They sold on credit for twelve months, replenishing their stock twice a year from Boston, New York, Philadelphia and other Atlantic ports through sailing vessels that returned with cargoes of produce from the bayou country in exchange. They were obligated to carry heavy stocks of goods. Western products, such as flour, whiskey, soap, candles and more, were floated down the Mississippi and Atchafalaya in flatboats. The use of cured meats such as pork, bacon and ham was almost unheard of in those days.

Alfred Duperier was considered one of the finest citizens of New Iberia. Besides being a physician, he was also a sugarcane planter on his beautiful and extensive Morbihan Plantation, which was located about two and a half miles downriver from New Iberia near the hamlet of Olivier. Duperier was the first to introduce "modern sugar apparatus, vacuum pans and centrifugal" use in the sugar process. At the time of his death, the property was owned by New Iberia Sugar Company, in which he held an interest. Before the War Between the States, Dr. Duperier was an earnest supporter of the Whig Party. He was a staunch Unionist and Republican. During the war, he supported the U.S. government and was a trusted friend of Abraham Lincoln, Charles Sumner and Steven A. Douglas, for whom he named a son.

Dr. Duperier married twice. His first wife bore him a daughter. His second wife was Emma Mille, who lost her mother, father, brother, sister-in-law and infant niece all in one fell swoop, victims of the great storm of 1856, which is purported to be Louisiana's first major hurricane. Thirty-year-old Dr. Duperier and nineteen-year-old Emma Mille underwent one of the most horrible experiences on Isle Derniéré (Last Island), twenty miles south of Louisiana's Gulf Coast. Fortunately, they survived their ordeal and lived to tell about it. The two later married and had five children.

One of the first immigrants to settle in the area of New Iberia was John D. Wilkins of Virginia. Wilkins was said to be a great reader and

a friend of the young doctor who displayed ambition. When Dr. Alfred Duperier first began his practice, Wilkins offered the young physician a horse and buggy and gave him $500 to get started in his new business. Alfred Duperier advocated for an improved system of drainage that would secure the agricultural interest in Iberia Parish against crop failures from excessive or prolonged rains during the year. He proposed cutting a canal at least one hundred feet wide from the crest of Bayou Teche to tidewater. He estimated that as much as thirty thousand acres of land adjacent to New Iberia was unproductive. Dr. Duperier equated that amount to a commercial value of $1.25 million in agricultural products. It represented an increase in value of $20 per acre of land. He also envisioned electric tramways, saying they would be cheaper to operate in the end than the present expensive and unsatisfactory system of roads.

Dr. Duperier's beloved Iberia boasted of an inexhaustible supply of hardwood lumber. During his lifetime, there were still great quantities of cypress. It had great fishing in numerous streams scattered about the parish, not to mention the gulf with an abundance of seafood. It was a natural home for oranges, figs and pecans nourished by some of the most fertile soil coupled with nearly perfect growing seasons. It had two of the largest pure rock salt mines in Louisiana, as well as two of the finest wildlife game sanctuaries—McIlhenny Preserve at Avery Island and Russell Sage Preserve on Marsh Island. Iberia was located on the main track of the Southern Pacific Railroad only 125 miles from New Orleans, and it had the New Iberia & Vermilion (NI&V) Railroad along with the Franklin & Abbeville (F&A). Back then, it also had an electric trolley line that ran from New Iberia to Jeanerette some 12 miles down the bayou. It also had a model automobile highway that paralleled the rail line. New Iberia or the immediate territory had sugar and rice mills, cotton gins, a creamery, lumber mills, Tabasco factories, feed mills, two corn elevators, foundry and machine shops, a box factory, two ice

St. Peter's cemetery, New Iberia, Louisiana. *Courtesy of William Thibodeaux.*

Duperier monument in St. Peter's cemetery, New Iberia. *Photograph by William Thibodeaux.*

factories, a steam laundry, a municipal electric and water works company and sash, blind and door factories.

Dr. Alfred Duperier died at his home at 8:30 on the morning of Wednesday, April 23, 1904, from complications from pneumonia and heart trouble. At the time of his death, he was reported to be the oldest physician in southwest Louisiana at seventy-eight. The funeral was held at St. Peter's Catholic Church in New Iberia, which was too small for the enormous crowd that gathered to pay its last respects. The local newspaper reported: "No person of our time has left a more vivid impression or whose memory will be cherished longer than this noble son of Iberia."

In the Blink of an Eye

On December 20, 1902, Ambroise Mouton, a twenty-three-year-old railroader from Lafayette, fell from a moving railcar while switching at Bayou Ramos. It was reported that Mouton's legs were crushed just above the knees. Bayou Ramos, at mile post 76.1, was midway between Morgan City (mile post 79.3) and Bayou Boeuf (mile post 73.3) on Southern Pacific's Morgan line. Conductor Ryan was in charge of the train and witnessed the accident, saying that Ambroise fell in front of the iron wheels. Ryan and a brakeman wrapped Mouton's legs with cloth to stop the bleeding, lifted the injured man into the caboose and laid him on a mattress that had been moved to the floor.

The train traveled to Morgan City, three miles west of where the accident occurred. Mouton was briefly given medical attention there and then was sent by rail to Algiers, across the Mississippi River from New Orleans. Some of the best medical doctors were located there. The agent at Morgan City sent a telegraph message alerting everyone including the train dispatcher of the tragic accident, thus assuring clear signals. Ambroise's family in Lafayette had also been notified of the accident. His mother, accompanied by Chas O. Mouton, was quickly loaded onto a passenger train and highballed to Algiers.

Ambroise Mouton had recently been hired by Southern Pacific and was in the process of qualifying as brakeman. Back in those days, a student brakeman made a number of trips across the railroad with different train crews in hopes of learning something from each of his assignments.

Once the student brakeman knew his job well, a conductor wrote a letter, usually to the assistant superintendent of the railroad, explaining that this man was ready for a written test to become brakeman. Ambroise wasn't being paid for the student trips, as was customary—the railroad wanted experienced employees.

Former SP superintendent and later general manager Raphael "Ray" Duplechain, who had hired out in the 1950s, said he had heard a story about when someone applied for work as a railroad brakeman. As the story goes, the interviewing company officer would invariably say, "Show me your hands." Back then, if you didn't have a finger or two missing or a mangled hand, you weren't experienced. Duplechain also said he heard the story about the unfortunate accident at Bayou Ramos many times from some of the old head trainmen. It was a constant reminder that anything could happen in a blink of an eye. Joseph "J.C." Moreaux, a retired safety officer for Southern Pacific and later Union Pacific, had been a railroad brakeman and conductor and remembered when he hired out in the 1950s. Back then on SP, student trips had been reduced from thirty to only ten nonpaid trips. J.C. Moreaux spent countless hours all over the country teaching safety to newly hired trainmen. He said, "Today's trainmen still participate in the railroad's time-honored tradition of student trips; however, now they are paid." Today's trainmen spend a lot of time in rules training, both in the classroom and the field.

Unfortunately, Ambroise Mouton died in the caboose at Algiers as a Catholic priest prayed at his side. According to an old newspaper article, later that evening, Mouton's body was placed on the 9:20 train headed for Lafayette. His mother had arrived at Algiers in time to board and make the westbound trip with her son. Ambroise Mouton's funeral took place the following day at the family residence, which was customary for the time. He was buried at 4:00 p.m. with the Reverend Father Julien Ravier Bollard presiding. According to the paper, the funeral was attended by a large crowd of sympathizers, friends, neighbors and members of the Brotherhood of Railroad Trainmen. The fire department, the Sontag Military Band and members of the Ancient Order of United Workmen (AOUW) were also present; Ambroise was a member. The AOUW was founded in 1868 by John Jordan Upchurch. Back then, no one insured railroad brakemen—the job was too dangerous. The AOUW was the first fraternal group to offer death benefits to its members.

In 1914, Babe Ruth made his baseball debut pitching for the Red Sox, and the U.S. Post Office began using automobiles to collect and deliver

College Avenue (University Avenue), Lafayette, around 1900. *Courtesy of Lafayette Parish clerk of court Louis J. Perret.*

mail. The most popular movie of the year was *The Perils of Pauline*, a silent film featuring Pearl White and directed by Louis J. Gasnier. This year also saw rail employment nearing the height of two million workers nationally. Unfortunately, it was also the year Galbert P. Patin, a native of Lafayette, was killed in a railroad accident at Mermentau, Louisiana. Patin was employed by SP as a locomotive fireman. He was killed at 3:00 p.m. on Saturday, October 17, 1914, while switching railcars on the Mermentau wharf (mile post 180.1). Patin was riding on the fireman's side of the locomotive when the engine capsized. Locomotive engineer James Welsh was at the throttle and received only minor injuries.

Mermentau is a town at the western boundary of Acadia Parish. It was on SP's main track, which was a part of the old Lafayette Division, commonly referred to as the Louisiana Western (LW) Railroad. It is approximately forty-five miles west of Lafayette, which was the division headquarters at the time of the accident. According to the *Daily Advertiser*, on the day of Patin's accident, the crew's engine wasn't the one it normally worked with. This locomotive was newer and larger. It was also reported that the accident was "caused by the weakness of the wharf track." The condition of the track coupled with engine dynamics of a larger locomotive may have contributed

to the deadly accident. However, there was no mention of any formal investigation following the accident.

Patin's body was returned to Lafayette on the Oriole Express, one of several SP passenger trains during the railroad's heyday. The *Lafayette Daily Advertiser* reported that Galbert Patin was well liked by all who knew him. St. John's Cathedral in Lafayette was filled to capacity with family, friends and members from the Woodmen of the World and from the Camellia Lodge of the Brotherhood of Locomotive Firemen and Enginemen (BLF&E), which later united to form the United Transportation Union (UTU).

SP interchanged freight with riverboats at the Mermentau wharf. It was the gateway to the Gulf of Mexico, and paddle-wheelers such as the *Olive* and the *White Lily* worked the cattle and freight trade between Mermentau and Grand Chênière on Louisiana's gulf coast. Reports show that as early as 1874, the *Olive* was plying the waters of the Mermentau. During that era, Laurent Sturlese, a wealthy merchant from Grand Chênière, sent his three young daughters to Mount Carmel of Lafayette. The girls often rode the *Olive* from Grand Chênière to Lake Mermentau, today's Lake Arthur. From there, it was a day's travel by stagecoach to the school in Lafayette. Ribbons of steel across the prairies of southwest Louisiana were still several years into the future.

Several years ago, I met Jack Patin while writing this story. Jack is the only grandson of Galbert Patin. Jack informed me that his grandfather was born on November 2, 1881, and was married to Georgie Whittington of Glenmora, Louisiana. The couple was married on July 27, 1901, and had been married thirteen years and living in Lafayette at the time of the unfortunate accident. Patin left behind his widow and six minor children—five girls and a boy. The boy was George, who later became Jack's father. Galbert Patin's widow continued to live in the family home on the corner of Evangeline Thruway and Third Street in Lafayette, where an auto parts is located. She rented rooms to railroaders while at their away-from-home terminal. As a young boy, Jack Patin remembered how the trainmen would simply leave money on the kitchen table before leaving for work. They left either twenty-five or fifty cents per night. Due to the erratic train schedules and hours of service for trainmen, the house was never locked. "There wasn't even a key for the back door," said Madeleine, Jack's wife. How times have changed.

Approximately three years after Galbert Patin's death, his widow married Thomas Poleynard, a native of St. Martinville, approximately fifteen miles southeast of Lafayette in St. Martin Parish. Jack's grandmother met

Poleynard at the icehouse where he worked on Pierce Street near the railroad track in Lafayette. Back before electric refrigeration, everyone owned an ice box. A horse-drawn wagon would make its rounds delivering ice door to door. Jack's grandmother walked to the icehouse and purchased ice each day. "At first, she wasn't a very good cook," said Jack. "She wasn't from around here; however, she did learn and became an excellent cook. She also taught her daughters how to cook great meals." Poleynard helped raise Galbert's six children like his own. According to Jack, Poleynard had a great personality and always had a smile on his face. And profanity wasn't in his vocabulary; neither was the word *no*. "He was one of the nicest men I had ever met," said Jack.

Jack's father, on the other hand, was a different story. He was a real terror while growing up. As a young man, George Patin had a destructive personality. "He quit school the year before his graduation. And from the time he was 11 to the age of 65, he smoked four and one-half packs of cigarettes every day along with 30 cups of coffee. He ingested everything that wasn't healthy and rejected the ones that were," said Jack. George married Enola Landry of Nina, near Henderson, Louisiana, which was the best decision he ever made. He owned George's liquor store and later opened Smokey's Bar-B-Que behind the family home. Over the years, Jack would often ask his father about the incident that took Jack's grandfather's life. The answer was always the same—George was only two years old at the time and couldn't remember anything about Galbert. The only thing family members knew was that Galbert Patin died at Mermentau in a train accident. The family has since learned that Galbert died when his locomotive capsized while switching railcars at Mermentau. As for George Patin, somehow despite all that had happened to him, he managed to live to the age of eighty-five.

Wednesday, March 16, 1927, started out as any ordinary spring morning for the crew of SP local no. 57. However, that quickly changed when its conductor was struck and killed by an oncoming passenger train. How could this happen, everyone wanted to know. The *Lafayette Advertiser* of Saturday, March 19, 1927, reported that conductor Walter J. Donlon Sr. had stepped from his train in the rail yard at Rayne and was signaling the other crew members of his train, which was on a curved section of track. Donlon's back was turned toward passenger train no. 6 and failed to notice its approach. Donlon sustained a fractured skull and died instantly after being struck by the locomotive and thrown from the railroad. His body was placed on passenger train no. 6 and taken to Lafayette.

Pinhook Bridge. Lafayette still had dirt streets. Notice the sharp curve ahead of the bridge. *Courtesy of Lafayette Parish clerk of court Louis J. Perret.*

Earlier that morning, SP local no. 57 was called to leave Lafayette at 6:00 a.m. and had left sometime later. The local headed to Rayne, some fifteen miles west of Lafayette on the LW. Once there, it cleared the main track and entered one of the yard tracks. According to Southern Pacific Time Table No. 61, which took effect on November 12, 1922, passenger train no. 6 was scheduled to depart Rayne at 9:39 a.m. The fatal accident happened at 9:50 a.m. According to the *Crowley Signal* of March 16, 1927, the local had been "switching near the western corporation limits of Rayne near the Gulf oil station, west of the water tank" when the accident happened. Dr. John P. Mauboules of Rayne, in the absence of coroner Z.J. Francez of Crowley, viewed the remains and advised the crew to place the body aboard the train and proceed to Lafayette. At Lafayette, Dr. Mark Mouton, the parish coroner, also viewed the body. No inquest was necessary.

Nowhere in the article did it mention the exact mile post location where the accident occurred, nor did it name the track Donlon's train had cleared while waiting for the passenger train. The track speed back then was fifty-five miles per hour. Donlon was not a new hire; he had been around trains and railroads for nearly two decades prior to the fatal accident. He had been employed by the railroad since 1911, and he had celebrated his fortieth

birthday just two months earlier. He was the assigned conductor on local no. 57 at that time, but he held the position of brakeman at other times.

Walter J. Donlon Sr. was survived by his wife and three children, who were twelve, nine and seven years of age. Their names were Walter J. Jr., Lewis "Babe" and Genevieve. Walter Donlon was also survived by his parents, Benjamin J. Donlon and the former Marie Charlotte Billeaud, and four sisters: Alice, married to Frank Doerr, Camille, married to B.C. Grunewald, and Rhena Donlon, all of Lafayette; and Lottie, married to D.A. Ritchey of Jackson, Mississippi; and one brother, Mike Donlon, a well-known insurance and real estate man and president of the Lafayette Chamber of Commerce. Funeral services were held the following day (Thursday) at 3:00 p.m. at St. John's Cathedral in Lafayette. The church was packed with family and friends along with a large group of members from the Order of Railway Conductors and Brotherhood of Railway Trainmen, of which Donlon had been a member for a number of years.

In the days of Walter Donlon, the depot in Rayne was a viable train order station. The depot had a telegraph operator who remained on duty from 12:01 a.m. to 8:00 a.m. and again from 11:00 a.m. to 7:00 p.m. six days a week—and closed on Sundays. It was located at mile post 160—160 miles west of Algiers. Special thanks to Camille Copeland of Lafayette, a granddaughter of Mike Donlon, Walter's brother. Also thanks to Paul Raymond Breaux, who compiled the Donlon family genealogy.

THE MEDLENKA RIVER

Have you ever heard of the Medlenka River? Did you know that Crowley was once a river port? For years, just west of the center of Crowley, there was a large wooden wharf to accommodate river traffic. Back then, Crowley was billed as the gateway to the Gulf of Mexico. A newspaper article more than a hundred years ago read: "Crowley, the largest city on the Intercostal Canal, with freight and passenger boats." Perhaps Crowley had hoped to persuade the federal government to shift the proposed Intracoastal Canal farther north from its projected location. The canal was talked about in America since the early 1800s. One of the proponents in southwest Louisiana was Joseph G. Medlenka. He came to Crowley when the town was first established in 1886. Back then, he was employed by Southern Pacific railroad as Crowley's first agent. He later became a lawyer and then a judge. Medlenka stated that he received his inspiration for a waterway after attending an annual interstate inland waterway league convention in Lake Charles. He saw a means of uniting all the streams flowing into the Gulf of Mexico from the Mississippi to the Rio Grande. Medlenka wanted Crowley to benefit from the great work, so immediately after the convention, he returned to Crowley with an idea. He inspected Bayou Plaquemine Brulé and concluded that Crowley could meet the Mermentau, its tributaries, the lower coast and the Intracoastal Canal with a little help. He sought the aid of ex-congressman Arsen P. Pujo from Louisiana's Seventh District.

A group of waterway promoters projected that millions of dollars' worth of merchandise could possibly travel up and down Bayou Plaquemine Brulé

Joseph G. Medlenka, originator and promoter of Medlenka River waterway project, was first a Southern Pacific depot agent. He studied law with an attorney in Crowley, became a lawyer and then became a judge. *Courtesy of Freeland Archives and Acadia Parish Library.*

annually—not to mention the much-needed population added to the census roles. A published report said there could possibly be an estimated 131,000 tons of freight worth approximately $6.6 million annually. The promoters of the waterway were hoping to include the help of all businesses in Crowley and someone to establish a steamship line to haul the freight. The promoters were also planning on local businesses along the bayous—Mermentau, des Cannes, Nez Pique, Lacassine and Que de Tortue—to bring their freight to the Crowley terminal. At that time, it was considered to be the most logical point for the headquarters of the new waterway. Although it seemed everyone wanted the waterway, it took several years to finally act on it.

On April 24, 1915, a meeting was held at the Crowley City Hall for the express purpose of planning a huge event scheduled for June 3. It was the Great Waterway Celebration to honor the opening of the river to the Gulf of Mexico, and it was projected to be the biggest event ever held for the citizens of Crowley. No expense was spared. A wharf was being constructed at the landing and would be completed in time for the big event. A crowd of ten thousand was expected. According to the *Crowley Signal* of April 25, 1915, preparations were even made "to grade the road from West Hutchinson Avenue to the landing!" At 11:00 a.m., guest speakers at the wharf terminal included Governor Luther E. Hall, other prominent leaders of Louisiana and J.G. Medlenka, the originator of the Crowley Waterway project. An impressive military parade was planned, followed by the fire department, "secret societies and prominent visitors in automobiles" then by a barbecue and basket picnic at 1:30 p.m. Lyons Park hosted a foot race and baseball games. A night parade was planned to feature "illuminated automobiles" since it had just become standard on American automobiles. A huge fireworks display ended with a grand ball.

Preparations were also made for a steamboat trip from Crowley to Grand Chênière on the Gulf Coast with an overnight stop at beautiful Lake Arthur.

The date was set for May 11, 12 and 13, 1915. A huge celebration was planned for local businesses there. The Crowley businessmen were planning to distribute advertisements and souvenirs. A brass band and orchestra were slated to accompany the boosters and perform on the bank of the Mermentau River at each stop. The band purchased new uniforms to make a big and lasting impression. It was anticipated that people would turn out en mass to receive them. According to tradition, the *White Lily*, which was considered the "best and largest boat on the Mermentau," was contracted for the trip.

On May 31, 1915, the citizens of Crowley recognized J.G. Medlenka's years of tireless service in developing a deep-water channel. A few days later, on June 5, Judge P.S. Pugh offered a resolution to change the name of Bayou Plaquemine Brûlé to Medlenka River in honor of Joseph G. Medlenka for his distinguished service rendered to the citizens of Crowley and the surrounding area. The resolution was voted on and overwhelmingly approved and adopted. City leaders said the water project would force the three railroad trunk lines operating in Crowley to lower their freight rates to accommodate the town. The Southern Pacific ran east and west on the main track between New Orleans and Houston. The Opelousas Gulf & Northeastern, or "Oh Gee" as it was commonly called, ran from Melville, Louisiana, to Opelousas, Church Point and Rayne and terminated at Crowley. The third rail line was the Eunice Branch, owned by the Missouri Pacific Railroad, that went from Eunice to Crowley.

Not everyone thought the railroad freight rates were too high. E.I. Addison, the owner of the *Meridional*, wrote an article several years earlier when some residents of Vermilion Parish were dissatisfied and thought the railroad freight rates were too high. He reminded them of "the good old days" when they were 150 miles by water from any railroad. Back then, a steamer arrived once a week. It was their only means of getting their produce to market and obtaining necessities and luxuries of life. He also remembered oftentimes seeing empty store shelves. He made a comparison of before and after the arrival of the railroad. He said before the railroad, his family had ordered a sewing machine from New Orleans, and the freight rate was three dollars. His family had recently ordered the same make and model sewing machine, but this time the railroad freight rate was sixty cents.

In December 1915, Congress ordered a preliminary survey of the stream near Crowley. By January 1916, the State Corps of Engineers sent several engineers to investigate the bayou. The average depth was eight feet, and the width was seventy feet. It was jammed with logs, driftwood

and overhanging tree branches, frequently making it necessary to drag a skiff over these impediments. There were many sharp bends and curves in the bayou that required straightening to make navigation safer and easier. The stream from Crowley to the mouth as it entered the Mermentau River showed a gradual increase in depth and width. At the mouth of the bayou, it was fifty feet deep and two hundred feet wide, which was acceptable. At the time, aid of $10,000 was considered enough to make the bayou navigable. The proposition seemed practical and feasible, and the projected tonnage more than justified the endeavor. Twice Congress appropriated additional funds amounting to $30,000, and by March 1916, the bayou was cleared of all obstructions. The federal government stood ready for more improvements but not until the people of Crowley demonstrated that the stream was utilized.

Jules Clement, owner and operator of a sawmill on Bayou des Cannes some ten miles from Crowley, contemplated establishing a lumberyard at the head of navigation on the Medlenka River. He planned to use a gasoline tugboat and barge to bring his product to market. At the time, Clement was producing cypress, pine and hardwood lumber at his mill. He also intended to utilize a shingle machine and a planing mill to supply finished lumber for market. In August 1916, a barge line was proposed by the G.B. Zeigler

A Medlenka River snag boat has completed clearing debris from the channel near Crowley around 1915. *Courtesy of Freeland Archives, and Acadia Parish Library.*

Medlenka River Terminal, Crowley, around 1915. *Courtesy of Freeland Archives and Acadia Parish Library.*

Company, which already was operating farther south in Louisiana. J.G. Medlenka stated that many rice farmers along the Medlenka River were asking when the barge line would be ready for operation. He also stated that W.H. Hunter of the Louisiana Irrigation and Mill Company said he would arrange to ship all rice raised by his company on the barge line. Medlenka anticipated heavy tonnage in rice and rice products and predicted shipments of coal, oil and lumber.

For reasons unknown, the Medlenka River concept never materialized. Even its name never caught on. I surmise that in 1916, the War to End All Wars continuing longer than anticipated may have played a major role in the waterway's underutilization. By the time World War I ended, it was the era of the Roaring Twenties—a period of sustained economic prosperity— and no one cared about railroad freight rates. The average river traffic today is less than ten thousand tons of freight annually, mostly crude oil.

DUDLEY J. LEBLANC

The Most Famous Cajun

There is so much to say and write about Dudley J. LeBlanc. He was born on August 16, 1894, in the community of LeBlanc near Youngsville in Lafayette Parish. His parents moved to Erath when he was a baby. Both parents (Numa and Noemie) were LeBlancs, and neither spoke English. Despite not learning to speak English until the age of ten, Dudley became a very successful businessman. He was the genius who created a multi-million-dollar business, the Hadacol Company. Groucho Marx on his *You Bet Your Life* TV program once asked Dudley LeBlanc just what his Hadacol was good for. With a mischievous expression on his face and a twinkle in his eye, Dudley replied, "It was good for five million dollars last year." Within its first five years, sales increased to $2.3 million, and in 1951, Hadacol sales reached an all-time high of $25 million. Dudley was a great promotor. He knew what it took to sell his merchandise. He knew the path to fame and fortune was through advertising. The more you advertise, the more you're going to sell.

Dudley advertised big. He hired an entire train called the Hadacol Special. It was said that while on this train, Hank Williams created one of his greatest hits, "Jambalaya." Besides Hank, there was Bob Hope, Cesar Romero, Jimmy Durante, Lucille Ball, Minnie Pearl, Mickey Rooney, Roy Acuff and the Smoky Mountain Boys and many of Hollywood's leading ladies and other celebrities. The train stopped at a different city each night. Thousands of people packed the shows. The cost for admission was one Hadacol box top. And for the grand finale after each Hadacol show, the audience was treated to a dazzling fireworks display the likes of which no one had ever

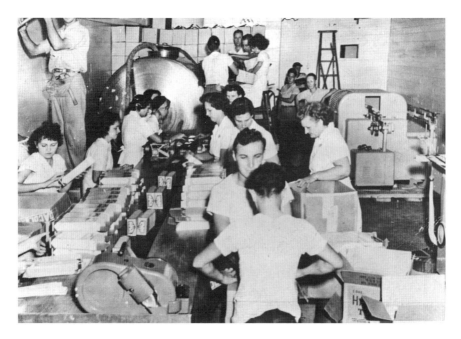

Filling bottles manually at the Hadacol plant, Lafayette, 1947. *Courtesy of Lafayette Parish clerk of court Louis J. Perret.*

seen. It was a lifetime memory for everyone in attendance. LeBlanc was also a staunch promoter of the Cajun language and its culture, and he was president of the Association of Louisiana Acadians. He is credited with the creation of the first public park in Louisiana, the Evangeline State Park, with his senate bill 297, sponsored by Dudley during Earl Long's administration. He also authored several fascinating books, including *The True Story of the Acadians*, written in 1927.

During the 1920s and 1930s, to be Cajun meant you were looked down upon as an inferior. Dudley LeBlanc changed all that. He is the one person responsible for the rebirth of Cajun pride. Dudley led the first official Louisiana delegation to visit the Acadians' ancestral homeland in Acadie, today's Novia Scotia. On his thirty-sixth birthday, August 16, 1930, he (and his Evangelines) were photographed with President Hoover on a brief visit to Washington while traveling to Acadie. His Evangelines were in early Acadian-style clothing. Each young woman wore a sash identifying the city she represented. The goal of the pilgrimage was to bring together the Acadians of Louisiana and those of Acadie so they could unite and establish a historical bond to their ancestral past. They visited the site of the *Grand*

Dudley J. "Coozan Dud" LeBlanc (1894–1971), the Renaissance man. *Courtesy of Lafayette Parish clerk of court Louis J. Perret.*

Dérangement (the expulsion known in English as the Great Upheaval) in 1755. The Great Upheaval inspired Longfellow to immortalize the Acadians in his epic poem *Evangeline*, published in 1847.

"Coozan Dud," as he was often called, returned to Washington on the way to Acadie in 1936 with another delegation wearing Old World–style clothing and sashes, and they were photographed with President Franklin D. Roosevelt. In 1955, LeBlanc again led a large group of Acadians to Novia Scotia for the two-hundredth anniversary of the expulsion. In the early 1960s, Dudley yet again led a group of Acadians on a pilgrimage to Acadie, and as before, he and his Evangelines stopped in Washington, unannounced as usual, and were photographed. This time it was with President John F. Kennedy. It's been said that Dudley LeBlanc helped make Louisiana the only English-French bilingual state in the union—unlike John M. Parker, Louisiana's thirty-seventh governor, who in 1921 tried to suppress Cajun culture by issuing an edict banning the French language in Louisiana schools. As former UL professor Barry Ancelet said, "It was an act that caused more than a few young Cajun first graders to wet their pants because they could not ask permission to go to the restroom." It also caused countless Cajuns to be ashamed of who they were. Some were so embarrassed they changed their names or altered the pronunciation to be accepted by the "*Américains.*" Dudley LeBlanc broke the mindset of being passive and quiet.

The thing some of the more senior citizens from Acadiana remember about Coozan Dud was his Sunday afternoon radio show. His radio program began in the 1930s and lasted well into his twilight years. He always began: "*Monsieur et madame, et mes chers amis.*" His show began at 12:30 in the afternoon, and the first thirty minutes were totally in French followed by thirty minutes of English. He kept his loyal followers informed as to what was happening nationally as well as what was going on closer to home. In 1944, Dudley also informed his listeners about World War II along with national and local politics. As a way of keeping his listeners coming back for more, he would invite them to tune in next week and he would tell them what this public official was doing or what that public figure said.

People wait on Dudley's Hadacol Special. Brown News was an old Lafayette landmark used as Southern Pacific Railroad's Lafayette Division headquarters for many years. It was demolished around the 1960s. Dudley J. LeBlanc was a frequent train rider, especially on his Hadacol Caravan Train. *Courtesy of Lafayette Parish clerk of court Louis J. Perret.*

My father, the late Wilson Thibodeaux of Rayne, told me on more than one occasion about Dudley's radio program. When he was a young boy, every Sunday afternoon, a crowd of people gathered at the home of Noah Stelly near the community of Bosco in northeastern Acadia Parish. Noah was a well-respected cotton farmer and probably the only one in that area who owned a battery-powered radio. My father said the women would sit and talk inside the house with their friends and neighbors, while outside on the large wooden porch, the menfolk talked about cotton prices, the weather and politics. But when the person on the radio began to speak, everyone listened, and you didn't dare interrupt. The voice on the radio was Dudley J. LeBlanc. Coozan Dud was well liked by most Cajuns because he was one of them. He spoke their language.

Another time when Dudley was on Groucho Marx's TV program along with a young attractive blonde, Groucho asked her if she knew who her senator was. With an embarrassed look on her face, she responded that she did not. Dudley, always a gentleman, came to her rescue. He stated it wasn't her fault that she didn't know who her senator was—it was her senator's fault. Dudley said, "Everyone in Louisiana knows who I am." Dudley was a great promoter who made himself known throughout Louisiana and most of the country. In 1948, during Earl K. Long's administration and while Dudley was state senator, his twenty-four-year-old dream of an old

Left: Tomb of Dudley J. LeBlanc at St. Mary Magdalen Catholic Church in Abbeville. *Courtesy of William Thibodeaux.*

Right: Louisiana state senator Dudley J. LeBlanc and Representative O.C. Guilliot, with the state capitol in Baton Rouge in rear. *Courtesy of Lafayette Parish clerk of court Louis J. Perret.*

age pension was finally realized. During Dudley's long tenure in the senate, he helped many people get elected simply because he was Dudley and he was trusted. In 1959, he was recruited by Governor Jimmy Davis for his re-election campaign, which Dudley heartily accepted. While promoting Jimmy Davis, Coozan Dud also promoted Cajun culture. He invited prominent politicians, including Harry Truman and John F. Kennedy, to meet Cajun voters. During Kennedy's 1960 presidential campaign he visited southwest Louisiana. LeBlanc promoted Cajuns in general and as well as the oil industry, livestock, seafood and the rice industry.

On October 22, 1971, Dudley J. LeBlanc died from a massive heart attack while campaigning for his senate seat. He was seventy-seven, and reportedly his last words were, "Take care of my people." Dudley was survived by his wife of fifty years, the former Evelin Hebert and their six adult children—four sons and two daughters. Dudley J. LeBlanc is buried at St. Mary Magdalen Parish Cemetery in Abbeville. His public service spanned ten governors and countless state senators and representatives.

RECOLLECTIONS OF WAR

Charles Frederick, a native of Erath, wrote Recollections of the Great Civil War in the *Abbeville Meridional*. It was a series of three articles that was published beginning on July 3, 1926, when Charles was eighty-one years of age and probably feeling a little patriotic. Louisiana seceded from the Union on January 26, 1861, and Charles Frederick enlisted in the Confederate army on July 16 of the same year, three months shy of his seventeenth birthday. Charles left his home and reported to Camp Pratt, a recruiting and training center near New Iberia on Spanish Lake. He met a lot of familiar faces there. Achille Berrard was in charge of the camp and made certain his recruits attended church every Sunday. After a few weeks of training, they were ready for full military duty. Charles and the other recruits boarded a steamer at New Iberia for a daylong boat ride to Camp Berwick. While at Berwick, they were given equipment, which consisted of a gun, one suit of clothes, one blanket and a garment bag—no shoes or hat were issued.

Visions of war were apparent when they learned that Federal troops were stationed in Thibodaux. Charles Frederick and his comrades boarded an eastbound train at Camp Berwick and headed for Thibodaux. The train ride was short-lived—after only ten miles, they had to march, as Yankee soldiers had torn up the railroad to delay their progress. Shortly before their arrival in Thibodaux, a group of German settlers was found guilty of treason for assisting Union forces in their looting. The citizens of Thibodaux made complaints, and the Germans were immediately arrested, tried

by Confederate military court martial and found guilty. Charles had the misfortune to witness the execution by firing squad. The condemned were lined along a ditch that also served as a mass grave. Charles said, "At the first fire the greater number fell backward into the ditch and needed no further attention. Others that were not killed outright were later dispatched by the burial squad, to whom fell the disagreeable duty of covering up the horrors of civilized warfare."

A few days after the incident at Thibodaux, Charles Frederick's unit was engaged in a brisk skirmish at "Pain Court" (Paincourtville), twenty miles northwest of Thibodaux. Colonel Valsin Fontenot was the first to spot a Union lookout on top of the tallest building. Captain Simms immediately opened fire on the shooter. He missed with his first shot but hit the mark on the second. A few minutes later, when the skirmish was over, Charles viewed the body of the sniper—his telescope was still in hand. Soon after the skirmish, Charles was stricken with measles. He was put on a cot under a large tree. Later Charles was moved to an abandoned sugar mill that had been cleaned out and was being used as a hospital. About a week later, a large portion of his company was also afflicted with measles. They were all sent to the hospital in Thibodaux.

Once he fully recovered from his illness, he rejoined his company at German Bayou. A few days later, they encountered Union troops at Abbeville, but the Confederates were badly outnumbered. General Alfred Mouton sent Willie Mouton with orders for Charles Frederick's company to retreat to the safety of Bislin. On Bayou Teche was the site of a fierce gunboat battle that lasted several days. On the first day, four Federal gunboats faced off with the Confederate gunboat *Cotton*, commanded by Captain Emelious Fuller. According to Charles, the *Cotton* was well equipped for river warfare—the front and sides were protected with iron rails. Charles was detailed to hold a bridge that spanned Bayou Teche with instructions to open the bridge when the *Cotton* arrived and to immediately close it against all enemy boats. Several of *Cotton*'s Rebels were killed and fourteen others seriously wounded, including Captain Fuller, who had a broken arm and a broken leg. After receiving first aid, he was taken back on board, where he continued to direct the fight. It was all for nothing. The Federals' firepower proved too much for the *Cotton*. It retreated for the last time, blowing its whistle as Frederick opened the bridge. The *Cotton* was so badly damaged it sank just before arriving at the bridge.

The date may have been April 12, 1863, when Charles Frederick and his comrades returned to Fort Bislin. Captain Simms was stationed at Bislin and

was in command of a number of cannons. A company of Yankee soldiers had taken possession of the Bislin House, which was considered a very valuable piece of property. The Federals had a few cannons with them and began firing on Captain Simms's forces with deadly accuracy. Simms debated how to best force the Feds out of their stronghold without destroying the house. At about that moment, the Federals shot and killed Simms's best horse. This so enraged Simms that he had his cannon trained on the Beslin House. An iron cannonball was heated until it glowed red, and then it was fired at the Feds, who quickly vacated the home. The Rebels gave chase as far as Bayou Sally (Salé), when it became too dark to continue. Charles remembered that night because it was the worst in all of his experiences during the war. It had rained all day; they were drenched along with their bedding and clothes. To make matters worse, a cold front had moved in, and they had no means to make a fire. They chopped palmettos and used them as their beds. The following morning, their bedding was covered with ice. It was so miserable that they gave up the pursuit and returned to Fort Bislin.

The following night, while at Bislin, Charles was placed on picket guard duty, and his stand was in a ditch about two hundred yards from the fort. All night long, he wondered why he wasn't relieved of duty. The next morning, when Charles arrived at the fort, he got his answer. It had been abandoned during the night, and no one had bothered to tell the guards. The officer in charge of the picket guards gave orders to move out. After a short distance, they heard someone shouting. When they looked back, the Federal troops had taken the fort and were waving them to return. Charles remembered how that gesture was so nice of the Yankees, but they kindly refused and kept on their way toward Franklin. While in Franklin, they were down to one hundred men, and Joe Leblanc was now in charge. They soon learned that they were caught in a crossfire between Union forces and a company of Texas cavalry, which helped keep the Yankees at bay. Charles and his companions were able to skirt outside of Franklin. "The people in town showed them every consideration possible—opening gates and pointing out the shortest and safest routes to safety."

Later, Charles was stationed at the salt mine at Avery Island on guard duty. While there, he developed a severe case of "bone-felon" (infection) on the fingertips of his right hand. He was given permission to return home to recover. He was at the home of his godfather, Armilien Primeaux, when he was informed of a detachment of Yankees positioned in Abbeville. The Eighteenth Louisiana Regiment was hiding out in Primeaux's fields east of Abbeville. Back in 1926, that property was known as Basile Broussard's place.

Charles was afraid the Confederates might be captured, so he quickly rode out to inform the Rebels. Instead of retreating to safety, they immediately set out to confront the Yankees. Charles followed the regiment more out of curiosity than anything else. According to him, the two opposing forces met at the north end of Grosse Isle at the farm of Lufroy Toups, Charles's old uncle. A sharp engagement ensued, and Charles was taken prisoner. Charles assured the Yankees that he was not the enemy, but they took him along anyway. He was held as a prisoner of war at New Iberia for fifteen days. While in custody, Charles Frederick was allowed a certain amount of liberty. He made his getaway by hiding in a corncrib just before the Feds were preparing to leave town. The Yankees made a cursory inspection, but Charles remained undetected as they marched out of town.

Charles then returned to his unit at the salt mine. By this time, Lieutenant Burke was in command, and the unit was being transferred to the Eighteenth Louisiana Regiment with instructions to report to Alexandria, Louisiana. There was nearly continuous battle at New Iberia as they made their retreat toward Mansfield. Charles and other Confederates arrived at Grand River with the Yankees following close behind and crossed a pontoon bridge that had been prepared for that purpose. Once safely on the other side, they torched the bridge and hid their horses at a nearby cotton gin. It was the largest gin Charles had ever seen and was conveniently located near the river. The Confederates quietly waited at the levee for the arrival of the Yankees. Colonel Vincent was in charge, and the regiment numbered about three hundred strong. They didn't have to wait long. The Yankees appeared on the opposite side of the river and unsuspectingly hurried down to the water's edge, where Vincent's soldiers opened fire. At that short a distance, every bullet seemed to hit its mark. The Federals began a full retreat, while Colonel Vincent's troops continued toward Mansfield.

On April 8, 1864, the Battle of Mansfield took place about three miles southeast of the town. The fighting began at 9:00 a.m., and by 3:00 p.m., the Federals were in full retreat. Charles and his comrades gave chase, but when they arrived at the main road, it was necessary to dismount and remove some of the bodies before proceeding. During the fighting at Mansfield, General Mouton was killed. General Jean-Jacques-Alfred-Alexandre Mouton was thirty-four years old and the eldest of former governor Alexandre Mouton's children. General Mouton left a wife, the former Alix Judice, and four children. His body was taken to a house in Mansfield and placed on the front porch, where it was viewed by practically all of the soldiers. A great number of Charles's friends were also killed

and wounded during the fighting at Mansfield. That night, the Federals pitched their camp near a creek some distance from Mansfield, which was probably the site of the bloodiest fighting for both sides. The Rebels attacked the Federal position at about 10:00 p.m., routing the Yankees and forcing them to retreat. The following night, a makeshift two-story hospital was burned to the ground. Inside were two hundred wounded soldiers, but miraculously, only one perished in the flames.

After Mansfield, Charles's unit was ordered to Pleasant Hill, where a battle had taken place a few days earlier on April 9. The Rebels learned that they had lost the great cavalry chief Tom Green, who was decapitated by a Union cannon shell. Pleasant Hill was located about sixteen miles southeast of Mansfield. Charles said things were very unpleasant at Pleasant Hill—revolting would best describe the scene. The air was filled with the stench of dead and decaying matter. Shortly after leaving Pleasant Hill, they arrived at Red River, where they attacked and killed eighty-six Yankees, including one woman. That same night, they had a brush with a gang of Jayhawkers—outlaws and deserters who were mostly Northern sympathizers. They managed to capture thirteen of the Jayhawkers. One was a boy of fourteen, who was released. The others weren't as fortunate. This was the second time Charles Frederick witnessed an execution by firing squad during his service in the military.

Charles was transferred to the Seventh Louisiana Regiment at Lafayette. A few days later, they were ordered across Morgan's Ferry on the Atchafalaya River, where they found the enemy heavily entrenched. After three days' battle, the Yankees were glad to wave the flag of truce. Charles was part of a detail assigned to meet the Federals to arrange terms of surrender. The captured Yankees were immediately taken to Opelousas, and Charles's unit quickly returned to Morgan's Ferry. After several uneventful days, they were notified about a large group of Yankees nearby. The following morning, they attacked the Federals ten miles downriver. It was on this day that John Coleman was killed. He was Charles's best friend. After the battle, forty of the Confederate soldiers became sick. They were sent to the hospital in Washington. After their discharge, they met their regiment at Ville Platte. They were ordered to do provost guard duty at Opelousas for fifteen days. Afterward, Charles's company was ordered to make war on the Jayhawkers, "who were committing unspeakable outrages on the defenseless people in the outlying districts." They made their way to Bayou Nezpique, where they came upon a group of Jayhawkers that had recently assaulted some women. The Rebels gave chase, killing one and giving the others a good scare. The following day, they captured one Jayhawker. After giving him time to plead

Charles Frederick, former
Confederate soldier from
Erath, around 1890.
*Courtesy of Warren Perrin, L.F.
Corrodi Photography.*

his case, the Confederates judged him guilty. The next day, they left him
hanging from a tree.

After spending an undetermined amount of time at Bayou Boeuf near
Natchitoches doing picket duty, Charles was assigned a detail for fifteen days
to get some beef for his men. Upon his successful return, Captain Whittaker
ordered Charles and other men to go to Bayou Lafourche and steal mules from
the Yankees. They were successful in taking the mules, but they were soon badly
outnumbered by the Yankees and had to turn the mules loose. They were down
to ten men and had to take a circular route through Plaquemine before losing the
Yanks. They made their way to Jeanerette, where they got horses and returned
to Camp Brenger near Lafayette. They remained at the camp for ten days before
being ordered to Alexandria. While on their way there, they received word that
peace had been declared. A short while later, Charles Frederick was mustered
out of service and returned home to Erath. At the very end of Charles's story,
he gives a complete list of his company, Company E.

County-Parish and the Creation of Evangeline Parish

P eople often ask why Louisiana has parishes instead of counties like other states. We had counties in Louisiana for a while, and we also had counties and parishes simultaneously. Louisiana was formed from French and Spanish colonies, which were both officially Roman Catholic, so local government was based on parishes. Our county system began less than two years after the signing of the Louisiana Purchase, which took place in New Orleans on December 20, 1803. W.C.C. Claiborne of the Mississippi Territory was given custody of the newly acquired land by President Thomas Jefferson. Claiborne exercised the powers of governor general and assured the inhabitants that they would be protected and would enjoy their liberty, property and the religion of their choosing.

According to *The Origin and Early Development of County-Parish Government in Louisiana*, by Robert Dabney Calhoun, nearly a year later, the region was organized into the territory of Orleans, most of which became the state of Louisiana. The territory had not yet been surveyed or chartered. That would not happen for another eleven years. The Orleans Territory had a population of forty-five thousand and was, as it has always been, predominantly French. The city of New Orleans had a population of around ten thousand, mostly from France or their descendants, who spoke Parisian French. There was a small percentage of Canadian and Acadian French and French refugees from Saint-Domingue. The Spanish population was small, consisting mainly of officials and soldiers or their descendants. There were a few Americans and others from Western Europe. There were people from the West Indies,

and there was also a large population of slaves and *gens de couleur libres* (free men of color). Outside New Orleans, there were twenty distinct zones or rural settlements within the present state of Louisiana.

The thirteen members of a newly created legislative council held their first session on December 4, 1804. One of the first things the legislature did was to divide the territory into governmental subdivisions for the administration of local affairs. The United States had been in possession of Louisiana for more than a year, and vast areas of the interior of the country were entirely unsettled and practically unknown. When the legislative council met for the second time, on April 10, 1805, many laws were passed, including the rearrangement of parish subdivisions. Parishes had been in place since the time when the French and Spanish occupied Louisiana. In 1805, they were changed to the American county system. The former territory of Orleans was divided into twelve Catholic counties, except for Concordia in north Louisiana, where there were few Catholics at the time. The others were Orleans, German Coast, Lafourche, Iberville, Pointe Coupee, Attakapas, Opelousas, Natchitoches, Rapides, Ouachita and Acadia. The legislative act further provided that each court of each county shall determine the seat of justice in such a manner that would be most convenient for the residents of each county.

Each of the twelve counties was composed of a specific Catholic parish except for Concordia. The parish church became the center of the community, and by virtue of being educated, the parish priest became the most important individual in the community. Among other things, the priest was counselor to the literate and adviser, accountant and scribe to the illiterate. Before this time, the Orleans Territory was a missionary country divided between the Jesuits and the Capuchins (the United States was considered a missionary field until 1918). On March 13, 1807, the Louisiana legislature again chose to make changes in the organization of local government. In order to establish a territorial judiciary, the legislature created nineteen subdivisions called parishes, presumably to indicate their different purpose from counties. The Attakapas region became the parish of Attakapas as well as the county of Attakapas and the ecclesiastic parish of St. Martin.

On April 30, 1812, Louisiana was the eighteenth state to enter the Union, and it was the first state created out of the Louisiana Purchase. William Darby, the great geographer and frontier traveler, surveyed and chartered Louisiana in 1816. Darby had been collecting and compiling material for eleven years for his Louisiana map. At the time, no one knew more about

Louisiana than him. Andrew Jackson, the seventh president of the United States, highly praised Darby's extensive work, saying his map of Louisiana was a far more accurate description than any other. Louisiana still had both counties and parishes, which was probably beginning to be confusing to everyone. Nevertheless, the system managed to remain in place until 1845; ever since then, the official term for Louisiana's primary civil divisions has been parishes. These original parishes were extremely large and were eventually subdivided to create other parishes. For example, Attakapas Parish was separated into five parishes and part of another: St Martin, St. Mary, Lafayette, Vermilion, Iberia and part of Cameron Parish.

No doubt the Louisiana Purchase was one of Thomas Jefferson's greatest achievements. It more than doubled the size of the United States at the time and cost a total of $15 million—less than five cents an acre. Today, Louisiana is divided into sixty-four parishes, and in 2012, it celebrated two hundred years of existence and prosperity. It is rich in food, culture, music and history with an abundance of valuable natural resources. One of the original twelve parishes was St. Landry Parish, which over the years became known as Imperial St. Landry Parish for its size. It stretched from the Atchafalaya River westward to the Sabine River and south to the Gulf of Mexico. Over the years, other parishes—Calcasieu, Acadia, Evangeline, Jeff Davis, Beauregard and Allen—were created from St. Landry Parish. I'm certain that each time a new area suggested division, there was a struggle. In 1909, St. Landry Parish was in another struggle to divide the parish yet again. This time it was for the parish of Evangeline. Talk of dividing the parish had been around since the mid-1880s, but it was just talk until about 1907. The main complaint regarding St. Landry Parish was its size—it was too large. Whenever records needed to be filed or business transacted, one had to travel to Opelousas, the parish seat. It was a long distance away, and there weren't many automobiles at that time. The following is a story about division and anti-division and the ensuing struggles to become a parish.

Remember the Southern Club? Not the dance hall, the original Southern Club—the promoters of dividing St. Landry Parish, led by Paulin L. Fontenot and O.E. Guillory. They organized the movement, and it gained so much traction that by early February 1909, an anti-division group was formed, led by Judge Gilbert L. Dupre and Sheriff Marion L. Swords. They made speeches appealing to both economical and sentimental reasons for preserving the mother parish. The opposition said carving St. Landry would be like carving Texas—it just wouldn't seem right. They also cautioned the promoters of division to be careful what they wished for. Dupre and Swords

said, "If those people [pro-divisionists] knew the economic danger involved, they would change their minds." The opposition believed that a new parish wouldn't be able to generate enough taxes to maintain its government.

At the time (February 1909), Ville Platte was the only city in the running for the seat of the proposed parish. By March, Eunice, Pine Prairie and Mamou had also thrown their hats into the ring. Speeches were made over the entire parish in French and English. There was a good bit of arguing about the legality of a new parish. As a result, an injunction was brought to the Louisiana Supreme Court, where the parish was said to be dissolved. The *St. Landry Clarion* was completely disgusted with the recent turn of events and said, "One had just as well cast his vote in Bayou Cocodrie as to vote in the election." Be that as it may, the elections were held on April 13, 1909, and as it turned out, the pro-divisionists won by 1,707 votes to 368. Paulin L. Fontenot and O.E. Guillory became the founders of Evangeline Parish. The newly created parish was 640 square miles, reported the June 4, 1910 *St Landry Clarion*, 15 square miles more than was necessary. The *St. Landry*

Eunice fights to be the seat of newly created Evangeline Parish around 1909. *Courtesy of Bevan Bros. Photography.*

Clarion fondly thought that it would be retributive justice if the seat of the newly created parish would be in either Eunice or Mamou instead of Ville Platte, where all the talk about division had originated.

Once it was decided that St. Landry Parish would be divided, the railroads in the area selected their favorite town as their candidate. At that time, railroads were in their prime. They crisscrossed Louisiana like never before or since. Opelousas had Southern Pacific (SP) running north and south, while the Colorado Southern, New Orleans & Pacific Railroad (CSNO&P) ran east and west. The Opelousas, Gulf & Northeastern Railroad (OG&NE) Railroad, also known simply as the "Oh-Gee" originated at Melville on the Texas & Pacific Railroad (T&P) and ran diagonally through the prairies southwestward to Opelousas and Rayne and terminated at Crowley. Eunice boasted four rail lines: the Chicago, Rock Island & Pacific (CRI&P) connection, the Louisiana East and West Railroad (LE&W), the New Orleans, Texas and Mexico (NOT&M) subdivision and the Missouri Pacific (MOP) Railroad. Ville Platte had a railroad line too. It had the Louisiana East & West Railroad (LE&W) and it originated in Bunkie and extended westward to Ville Platte and then south to Eunice. The Rock Island backed Pine Prairie for parish seat; Southern Pacific and Union Pacific both choose Ville Platte.

Although C.C. Duson was resident of neither St. Landry nor Evangeline Parish, the territory was where he had been the high sheriff for sixteen years. People knew and respected him. Duson had built several towns in Acadiana, including Mamou, Eunice and Crowley. His reputation as a town builder was in his favor, and his choice for parish seat was Mamou. People had long memories and remembered when Acadia Parish was formed. Duson had staked out Crowley when it existed only on paper. And just like magic, a town miraculously appeared on the barren prairies and became the parish seat. There was no telling what could be done with Mamou. Besides C.C. Duson, the town of Mamou also had the Haas family, the wealthiest men in the parish. Dr. J.A. Haas was president of the St. Landry State Bank. He was also treasurer of the Mamou Townsite Company. And the Haas family owned much of the town's property and adjacent countryside. That influence alone, it was believed, was enough to sway votes for Mamou. C.C. Duson intended to make Mamou accessible to the people of Chataignier in order to get their votes. According to the June 5, 1910 *St. Landry Clarion*, Duson paid for the construction of a road to link the two communities. Representative Paulin L. Fontenot, the author of the Evangeline bill in the legislature, had moved to Mamou, and it was believed that he would side

Texas & Pacific Railroad depot, Eunice, around 1909. *Courtesy of Bevan Bros. Photography.*

with the new town. He had formerly lived in Ville Platte. Eunice had the Lewis family, including Dr. M.D. Lewis and James J. Lewis. However, both were interested in property in Mamou.

There were numerous fights in Mamou on Election Day, but they were not election related. It was reported as being an old-fashioned *grande ronde* affair that took place at the Mamou precinct unofficially known as the Valcour Ardoin poll. The election was over, polls were closed, votes had been counted, and the returns were tabulated before the ruckus began. It was reported that Martin Medicis, a resident of the area, started it when he happened by with a jug of whiskey. He offered everyone a drink, and that's when the knives and shotguns were brought into play. Perrault Aucoin and René Lefleur were involved in a petty dispute, and as a result, Aucoin and Valcour Ardoin were stabbed, the former thought to be fatally. René Lefleur and Bussy Landry were both shot, and there was little hope for their recovery.

Several others were involved in the melee. It was said that all parties were on friendly terms previously, and the difficulty occurred only after too much "tangle foot" had been imbibed along with the elements of the Wild West.

Also in Mamou, there were reports of more ballots in the ballot box than there were voters on the list. Another irregularity was that 1,295 citizens who might have voted against division did not vote because the anti-division committee asked voters not to participate in the process. They claimed the election would be null and void. Division, it was said by those opposing separation, was due to every western town in St. Landry Parish wanting to be the parish seat. This belief became an apparent fact as the struggle for parish seat came to a vote in November 1909. At that time, there were three towns vying to be parish seat: Ville Platte, Eunice and Mamou. Since winning for dividing the parish, the *St. Landry Clarion* reported that a Ville Platte citizen had stated: "Now that we have won, we can afford to be nice and give back some of the territory over which so much fuss had been made. We will be willing to give back Faquetaique, Mallet, and Plaquemine Point….Eunice may be thrown in for lagniappe." Eunice had been an active participate in wanting to divide Imperial St. Landry Parish. Fearing to be left behind, Eunice brought the matter to Baton Rouge, stating it would never compromise with Ville Platte on the division lines, since the lost territory would assure Eunice losing the parish seat for certain. To the citizens of Eunice, it was an obvious choice—it had four prominent rail lines to accommodate commerce.

The suit filed to cancel division had been taken before the court. The judge ruled that Evangeline Parish had been created. The anti-divisionists weren't satisfied; they brought their issue to the Louisiana Supreme Court. Meanwhile, in Evangeline Parish, the election for parish seat was nearing. Political rallies were taking place every night with free barbecue and whiskey in every corner and cove of the parish. There were 2,439 registered voters in the parish. When Ville Platte won the election, people celebrated all night. Again, as in the division elections, there were allegations of irregularities. The November 13, 1909 *St. Landry Clarion* reported "Ville Platte Wins Parish Fight" by 51 votes. The total votes cast were over 2,000: 747 for Eunice, 475 for Mamou and 798 for Ville Platte. In the end, Eunice said that votes casted for Eunice had been counted for Ville Platte, and Ville Platte claimed that Eunice votes exceeded the registration numbers.

Letters began to flood Opelousas demanding annulment of division. Several letters were published in the *St. Landry Clarion*. Meanwhile, a letter from Mamou claiming to represent all of the western part of Evangeline

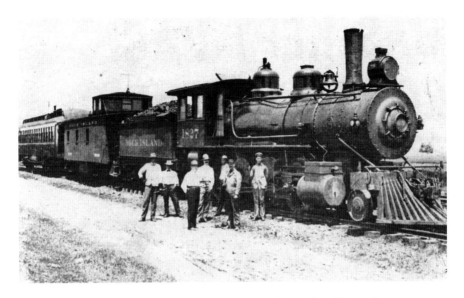

Rock Island Railroad, Mamou, around 1909. *Courtesy of Bevan Bros. Photography.*

Parish said, "We are ready to give you our hands to defeat division because we would rather go to Opelousas than Ville Platte….They have cheated us by wholesale." A letter from Basile stated, "God knows we don't want Ville Platte as our capital." Not to be outdone, a letter from Grand Point stated, "This election was simply controlled by money, whiskey, and misrepresentation of the people." The article concluded, "The poll book for the Grand Point precinct had several pages torn out of it."

The suit that had been filed months earlier, and now apparently had been forgotten by most, appeared before the Louisiana Supreme Court in January 1910. Its decision was that Evangeline Parish did not exist. Ville Platte delegates immediately appealed to the court for another hearing but were refused. Determined to get around the Louisiana Supreme Court, the delegates appealed to the state legislature to create Evangeline Parish outright. Their attempts resulted in a scandal in which Governor Jared Y. Sanders was reported to be making a deal with the Ville Platte committee to give them division and the parish seat if they would support his candidate for judge. There was a lot of arguing back and forth until a compromise was finally hammered out between St. Landry Parish and its western citizens.

As a result of that compromise, the parish boundary line was shifted north four miles along Bayou des Cannes, reported the June 4, 1910 *St. Landry Clarion*. Eunice, Faquetaique, Plaquemine Point and Mallet were returned

to the old parish. The act creating Evangeline Parish went into effect on January 1, 1911. In the end, only Mamou wasn't satisfied. To make matters worse, there was an empty courthouse square in the center of town as a daily reminder of what could have been. Back when C.C. Duson founded the town and was selling lots, he set aside the courthouse square because he believed it was a forgone conclusion that Mamou would be the parish seat. Mamou filed several lawsuits contesting the legality of the act creating Evangeline Parish, but it was all for naught. Several citizens predicted it would take the next fifty years to erase the scars and bitterness. It was the most vicious and prolonged political battle ever encountered on the prairies of southwest Louisiana. And now, when viewing a map of St. Landry Parish, people focus on that long, disfigured finger pointing to the west as a reminder.

A Chilling Tale of
War and Survival

Ralph LeBlanc was born on October 6, 1921, in Parks, Louisiana. His parents were Albert and Vienna LeBlanc. He grew up during the Great Depression in a French-speaking family that consisted of eleven children—five boys and two girls with two stepbrothers and two stepsisters. Ralph graduated from Breaux Bridge High School in 1939 and enlisted in the U.S. Navy on April 9, 1940. After completing bootcamp, he was transferred to aviation radio school at San Diego. On November 24, 1941, LeBlanc was transferred to Hawaii awaiting further assignment. On December 7, 1941, when the Japanese rained bombs on Pearl Harbor, LeBlanc—or "Frenchie" as he was called—was an aviation machinist mate stationed on Ford Island. When the first bomb was dropped, its arming propeller landed just outside of the hangar for PBYs. At the time, no one knew they were under attack. When the arming propeller fell to the ground, LeBlanc quickly picked it up. The tiny propeller was still hot enough to burn a fingerprint onto one of the blades. He kept the memento.

LeBlanc was a rear gunner on different bombers. He operated with several aircraft carriers, including the USS *Yorktown* (CV-5) and the USS *Enterprise* (CV-6). The *Yorktown* was sunk at the Battle of Midway in June 1942, while the *Enterprise* became the most decorated ship in the navy during World War II. LeBlanc was at the Marshall-Gilbert Island raids and the Battles of Tulagi, Coral Sea, Midway and Guadalcanal. Within a nine-month period, he was assigned to four different aircraft carriers. During his tour of duty, LeBlanc had three planes shot out from under him. The first time was when he was

Breaux Bridge basketball team, 1938. The boys wearing ties, Ralph LeBlanc (*top*) and Lowell Thomas "Sonny" Bernard, became naval aviators. *Courtesy of Buzz LeBlanc.*

on the *Pensacola* near Guadalcanal while operating with the First Marines. He spent eighteen hours in the ocean on a two-man life raft. Fleet Admiral William "Bull" Halsey though enough of him to recommend LeBlanc to naval flight school, where he earned his wings. He became a naval aviator and was again sent to the South Pacific. In June 1945, LeBlanc volunteered for covert "Black Cat" night missions against enemy shipping.

Japan finally surrendered on August 15, 1945. LeBlanc returned home to Parks sometime later, probably in early 1946. Within a week, his four brothers also returned home. All five had volunteered for military service. In 1946, LeBlanc flew PBMs off seaplane tenders: USS *Currituck* (AV-7) and USS *San Pablo* (AVP-30). Later in the year, while LeBlanc was still in the navy, Admiral Richard E. Byrd of Antarctic fame was looking for a few good experienced pilots for an Antarctic expedition. LeBlanc agreed to join the operation and was given temporary assigned duty on the USS *Pine Island* (AV-12), a seaplane tender. Three PBMs, minus the guns and ammo, were

Left to right LeBlanc brothers: Whitney, Clifton, Albert, Ralph and Lee Roy; mom Vienna and dad Albert are seated. *Courtesy of Buzz LeBlanc.*

assigned to the expedition. The Martin PBM Mariner was a large patrol bomber flying boat, 95 feet long with a wingspan of 128 feet. It was two stories high and floated on water. It held thirty thousand gallons of fuel and was capable of remaining in the air for twenty-eight hours. On November

George 1 around 1946. (*Top, left to right*) Owen McCarty, photographer; William Kearns, copilot; Ralph LeBlanc, plane commander; Maxwell Lopez, navigator; and W.K. Henderson, radioman; (*bottom, left to right*) J.D. Dickens, plane captain; Bill Warr, flight engineer; and James H. Robbins, radarman. *Courtesy of Buzz LeBlanc.*

23, 1946, LeBlanc began several test flights on his seaplane, *George 3*. After two days of testing, the wings of these giant planes were removed and stored on the *Pine Island* in order to cross the Panama Canal.

On December 2, 1946, the *Pine Island* sailed from Norfolk for the Antarctic expedition, officially titled the U.S. Navy Antarctic Developments Program. The operation was organized by Rear Admiral Richard E. Byrd Jr. It was a massive operation involving a task force of nearly five thousand men, twenty-three aircraft and thirteen ships, including an aircraft carrier and a submarine. Some reports say the operation was designed to train the U.S. Navy for a possible war with the Soviet Union in the Antarctic, and there were others who said it was a covert operation to conquer alleged secret underground Nazi facilities. Ten days after leaving Norfolk, the *Pine Island* crossed the equator en route to Antarctic. On December 16, 1946, the *Pine*

Island refueled from the USS *Canisteo*, a navy fleet oiler, and on Christmas Eve 1946, LeBlanc saw his first iceberg. Afterward, he and the ship's captain decorated the *Pine Island*'s Christmas tree.

On December 30, 1946, the *George 1*—one of three PBMs attached to Operation High Jump—piloted by Frenchie LeBlanc was long overdue. What made matters worse, search and rescue operations were delayed due to severe weather conditions. Finally, on January 13, 1946, the weather cleared enough to fly, and the wreckage was found on Thurston Island, Antarctica. Three of its crew members were dead, and five of the six survivors were injured, including LeBlanc, who received severe injuries and burns. The captain of the *Pine Island* was also with the crew as an observer. He received minor injuries. According to James Haskins Robbins, survivor of *George 1* and author of *Antarctic Mayday*, they were flying in a severe snowstorm with heavy fog when the radar failed to detect a snow-covered mountain range. Robbins said, "the uncharted area from the coast to 800 feet in altitude where we clipped a mountain ridge was such a gradual incline there was nothing for the radar to see." They were one hour away from base when they were due back when the *George 1* crashed, and several crewmembers were ejected from the plane on impact.

In 1987, Ralph LeBlanc told his incredible story during an interview with former Louisiana state senator James Fontenot from Vermilion Parish. The Council for the Development of French in Louisiana (CODOFIL) and Louisiana Public Broadcasting (LPB) sponsored the interview, which was conducted entirely *en français*, LeBlanc's first language as it was for most Acadians of that era. During the interview, LeBlanc said that in 1946, during Operation High Jump, they were searching for radium, a radioactive material. Antarctica was probably the last place on earth that had ever been searched. They used a device LeBlanc referred to as an "AQP-5 gear," which was used in the 1940s to search for minerals buried beneath the ice. The

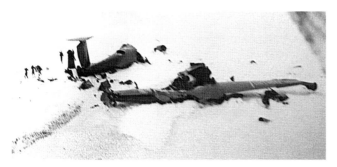

George 1 crash site, 1946. Three perished in the crash: Lopez, Frederick Williams (who replaced crew chief Dickens grounded due to toothache) and Wendell Henderson. *Courtesy of Buzz LeBlanc.*

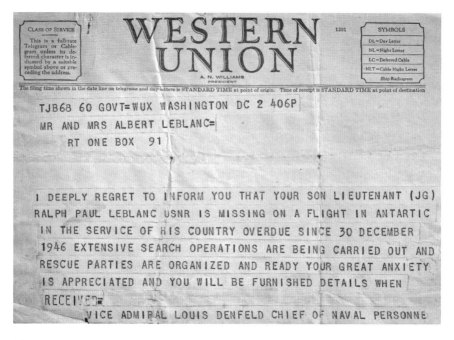

Western Union telegram informing Ralph's parents he was missing. The navy updated the family regularly by telegram. *Courtesy of Buzz LeBlanc.*

expedition also mapped Antarctica. No one had ever charted Antarctica to this degree before. LeBlanc said he and his crew were mapping an area from the coastline of Thurston Peninsula to the South Pole and back using trimetrogon cameras. Each leg, they would move laterally by about one hundred miles from their previous location and return to the coastline. The cameras would overlap the area by 10 percent. LeBlanc said afterward that it took scientists five years to develop and read all the charts they had accumulated during their operation in Antarctica. No one knew much about the continent back then. The only year-round inhabitants stand four feet tall and weigh eighty pounds—emperor penguins.

Scientists believed the frozen continent encompassed perhaps 7,000 square miles, or about the size of Massachusetts. They had badly misjudged its size. It was about 7 million square miles—larger than Europe and the United States combined. All landmass continuously moves ever so slightly. LeBlanc informed the interviewer that scientists believed Australia had separated from Antarctica ages ago and continued moving to where it is currently located today. He also said the South Pole is much different than

the North Pole. LeBlanc explained that the North Pole is a large piece of ice floating on water, whereas the South Pole is ice sitting on solid earth. There are mountain ranges, lakes and volcanoes on earth's southernmost continent, and most of it has never been seen by man. Archaeologists have found frozen trees buried beneath the ice and snow that have been there for countless millennia, which indicates that at some point ages ago, the climate was much milder. The South Pole sees the sun twenty-four hours a day during the southern summer. LeBlanc said each day was like 9:00 a.m. continuously. On clear days, he could see for what seemed like hundreds of endless miles. There is no rain, nor is there a speck of dust anywhere on the continent, said LeBlanc. While mapping Antarctica, scientists found an unfrozen lake 250 miles from the coastline buried deep under snow. One of the most remarkable things about the lake was its water temperature, which was 38 degrees Fahrenheit—compared to 60 degrees below zero just 300 feet above, the lake was quite warm indeed. Volcanic activity kept the water temperature above freezing.

During the interview, LeBlanc talked about that fateful day of December 30, 1946. He described their encounter with a snowstorm, or as he referred to it as "*un ouragan de neige*," which literally means a hurricane of snow or a violent snowstorm. They could not see four feet ahead. An ordinary compass doesn't work in the South Pole; the needle spins continuously because it's close to the magnetic south pole. LeBlanc mentioned that they tried three types of compasses, which all had setbacks. The only one that worked was what he called a sun compass, which operates by sunrays. On this day, due to the ouragan de neige, the compass didn't work, so they didn't know where they were or where they were headed. While flying several hundred feet above earth, ice formed on the wings. In order to eliminate the ice buildup, they reduced elevation. LeBlanc said a good rule of thumb is for every thousand feet of descent in altitude, temperature is reduced by five degrees. That was what they were attempting when the aircraft

Ralph recovering at Philadelphia Naval Hospital. *Courtesy of Buzz LeBlanc.*

scraped the top of a mountain range. At first, LeBlanc said it looked like they were going to come out of it okay because they kept flying, but then shortly thereafter an explosion occurred. He figured it was probably due to a lower fuel line that had been damaged when they scraped the ridge. The fuel and static electricity caused a fuel tank to explode. When they crashed, LeBlanc was suspended upside down by his harness. Once the seatbelt was unfastened, he dropped to the snow. A couple of members of the flight crew pulled him from the wreckage, which was in flames. Within thirty seconds, another fuel tank exploded and was engulfed in flames. LeBlanc was severely burned about the face, hands and back.

One member of the crew was thrown against the aircraft's bulkhead and probably suffered a broken back. Another was cut in half by one of the engine's propellers, and a third crewmember had one of the aircraft's engines fall on him. The surviving crewmembers were in a state of shock and didn't do much the first few days. Search and rescue teams were grounded because of the same snowstorm that LeBlanc and his crew had encountered. On the seventh day, the crash survivors wrapped the dead in parachute silk and buried them in a shallow, temporary grave under the starboard wing of the downed Mariner. When LeBlanc's aircraft went down, they had a thirty-day food supply on board, but a good portion of it was lost due to the explosion and subsequent fire. There was a Coleman stove to cook and melt snow for drinking. They also had plenty of fuel. The outside temperature during their thirteen-day ordeal was a frigid -90 degrees Fahrenheit. The snowstorm lasted for five days. Due to the severity of LeBlanc's burns, he was fed soup through a straw. Before the crash, LeBlanc was a robust young man of 195 pounds. When he and his crewmates were rescued, he weighed all of 95 pounds.

On the thirteenth day, they saw a search plane in the distance. James Robbins, author of *Antarctic Mayday*, poured 145 octane gasoline onto a life raft and lit it with a long-handled torch. It worked! A thick black smoke billowed high into the sky. The aircraft spotted the men, and a plan was quickly formulated. They weren't out of danger yet, not by a long shot. In addition to a ten-mile hike, they were eight hundred feet above where they needed to be. The men used a sled that was part of the emergency equipment, placed three sleeping bags on it and then placed Frenchie on the makeshift bed along with vital supplies. A thick fog was quickly developing over the lake, but fortunately, their descent was a gradual downhill grade. Besides the fog, there was one hundred feet of frigid water separating the downed crew from the rescue aircraft. Once they arrived at the lakebed,

a nine-man raft was waiting. Frenchie was loaded onto the raft first, and they paddled out to the aircraft, where he was safely lifted on board and placed on a bunk. By this time, LeBlanc was completely dehydrated, and the onboard corpsman did not understand what kept him alive. The aircraft lifted off without incident and returned to the *Pine Island*. Its medical staff did not think Lieutenant Ralph LeBlanc was going to survive. He was facing insurmountable odds.

On more than one occasion, Robbins mentioned that the "big guy in the sky" had a lot to do with their survival. The lake they had been rescued from was large enough to land a big PBM. Early on, they had clear visibility, and "there was no iceberg anywhere in sight," said Robbins. Suddenly, like magic, a huge iceberg appeared. Robbie added, "Without the iceberg, there would have been no way to get us out." On the day they were rescued, they had used all their food supply. Robbins has been a firm believer ever since. They all became true believers afterward. If LeBlanc was going to make it, he was sure to need additional help from above. The men were transferred from the *Pine Island* to the USS *Brownson* (DD-518) for medical treatment. A couple of the survivors suffered from frostbite. On Sunday morning, January 26, 1947, LeBlanc was transferred in a stretcher over rough water to the aircraft carrier USS *Philippine Sea* (CV-47). LeBlanc was under the care of Dr. Leonard P. Barber from San Diego, the senior medical officer of the *Philippine Sea*. Upon arrival, he received a message from his parents that read, "Received telegram. Very grateful to God for your rescue. The entire nation is praying for you and letters are pouring in from everyone. We are fine. Wishing you a speedy recovery from Mom and Dad and family." LeBlanc was in critical condition but was able to dictate his first letter home. On January 30, 1947, Lieutenant LeBlanc's life was in such danger that his parents were notified, and the decision was made to amputate both legs below the knees. The first operation was done the following day and the second on February 4. Dr. Barber wasn't worried about the amputations; what caused him nervousness was LeBlanc's weakened condition due to burns over most of his body and malnutrition during the thirteen days on ice. During his stay on the *Philippine Sea*, he had frequent visits from his four fellow survivors, Captain Henry H. Caldwell and Commander J.M. Peters from the *Pine Island* and Admiral Robert E. Byrd.

Dr. Barber never left his bedside. The doctor slept and ate in LeBlanc's sick bay quiet room on board the carrier. On one of Admiral Byrd's visits, LeBlanc was asleep when the admiral asked Dr. Barber, "Is Frenchie going to make it?" Dr. Barber said LeBlanc would probably last a dozen days for sure,

but beyond that, he wasn't certain. Once Admiral Byrd left, LeBlanc, who was supposed to be asleep, told Dr. Barber he shouldn't lie to an admiral. LeBlanc said it would take a lot more than that to kill a Cajun. Dr. Barber said, "Well then, I think you're going to make it." Throughout his entire stay on board the carrier, LeBlanc was said to have "shown remarkable fortitude and spirit throughout and is a perfect patient." Although he was improving rapidly, the twenty-four-hour watch was continued. The *Philippine Sea* steamed to Newport, Rhode Island, and from there, LeBlanc was taken to Philadelphia Naval Hospital. Dr. Barber stayed at his bedside for an additional fifteen days. LeBlanc spent two years recovering from his injuries. Sometime later, he was fitted with leg prostheses, and still later, he was given a 100 percent medical discharge. The pay in 1950 was $229.75 per month. Years later, LeBlanc found out that Dr. Barber had spent his personal leave time to be with him at the Philadelphia hospital.

In November 1947, LeBlanc signed a Metro-Goldwyn-Mayer release for a seventy-five-minute color feature picture on Operation High Jump. The navy used combat photographers to film the footage in the documentary. LeBlanc returned home to Breaux Bridge in 1948. Once home from his ordeal, he met Mary Daigle from Church Point—she was the girl next door. They talked between the backyard fence that separated them. They married and raised a large family of four boys and two girls. They were proud of their children's accomplishments—all were college educated. Three of their sons enlisted in the navy and became naval officers. One was a commander, one a lieutenant commander and one a lieutenant. One of the sons was assigned to the Sixth Fleet, one became an aviator, and the third was in the submarine service.

Ralph LeBlanc worked various jobs in Breaux Bridge—as a county agent and city clerk, at a bank and at the school board office, where he was a sales tax collector. He retired in October 1987, shortly after his interview with CODIFIL. Several years ago, retired educator Eric Castille, a native of Arnaudville and resident of Lafayette, remembered seeing Ralph LeBlanc in Breaux Bridge. "He walked with a slight shuffle, but managed to get around really well," said Castille. Plans have been in the works for some time to disinter the three bodies of the downed Mariner and bring them home. Ralph LeBlanc received numerous awards, among them the Distinguished Flying Cross, Purple Heart and five Air Metals. James Robbins, survivor of the *George 1* and author of *Antarctic Mayday*, said the following about his friend Ralph "Frenchie" LeBlanc: "LeBlanc's reputation had long preceded him as one of the Senior PBM Plane Commander's in the entire Navy (his

Ralph LeBlanc stands next to automobile with sisters Vienna (who is running in the photograph) and Ida (on the other side of the automobile). *Courtesy of Buzz LeBlanc.*

record still stands as the youngest Navy pilot ever to achieve this distinction), and those who know him considered him the very best." LeBlanc died on August 21, 1994, in Breaux Bridge at the age of seventy-two. Cape LeBlanc in Antarctica was named in his honor. Unfortunately, he never knew it. Today, the United States maintains the largest research base in Antarctica.

Chênière du Fond

Approximately five miles north of Rockefeller Reserve, on the southeast side of Grand Lake in Cameron Parish, southwest Louisiana, is a little-known island named Chênière du Fond. As a crow flies, it's about twenty miles directly south of Lake Arthur. A *chênière* is a ridge or grove of oak trees commonly found along Louisiana's coastline, and *du fond* means at the bottom or lower end. During its heyday, Chênière du Fond was one of the greatest fur-producing areas of south Louisiana. It was the boyhood home of Franklin Price of Lake Arthur, the youngest of eight children—six boys and two girls—born in a trapper's hut. Their names are: Elva, Warren, Alvin, Edwin, Lanah, Johnie, James and Franklin. The girls helped their mother with the cooking, cleaning and laundering. The boys learned from their father and grandfather the age-old tradition of making and repairing fishing nets, trotlines and hoop nets. They also learned to repair their fishing boats. The family tended to a large garden that provided all its vegetables. Franklin was born in the late 1930s and now makes his home in Lake Arthur.

Franklin's parents, Johnny and Leona (Guidry) Price, lived off their twenty-six sections of adjoining swampland on a lease from the Miami Corporation. There are 640 acres in one section, which equates to one square mile. The family has trapped fur and caught crabs, fish and shrimp for generations beginning with Ellis Price, the first Price to settle in Lake Arthur. While most young children were learning their ABCs, the Price children were learning how to make shrimp nets and crab traps. By age

four and five, the boys were running their father's fur traps barefoot, even during winter. Their feet were tough as shoe leather. Franklin said his oldest brother, Warren, purchased his first pair of shoes when he was called to serve his country during World War II.

During the summer months, they fished with trotlines and hoop nets. The catch was sold to Dwyer Price's fish market in Lake Arthur and to Jimmy Hayes's fish market in Lowry. At one time, Johnny Price trapped, fished and hunted gators with Jack Kershaw, the father of legendary Cajun fiddler Doug Kershaw. During winter, they trapped, mostly nutria. Nutria were brought to Louisiana from South America sometime in the 1930s by Edward M. McIlhenny of Avery Island. They multiply quickly and give birth two or three times a year, with litters of up to a dozen. "They're very productive animals," says Price. Once the animals were skinned and the furs ready for market, they were given to Alvin Dyson from Cameron Parish, who oversaw the fur trade in the area. From there, the pelts were brought to Steinburg Hide and Fur Company in New Orleans. Thirty percent of the hides was used as payment for their lease. Franklin says it was a hard life, but it was enjoyable at the same time. "Things were simple back then," said Price. "We always had things to keep us busy." The Price children were home schooled by their mother. Four of his siblings never set foot inside a schoolroom, and the ones who did attend school only did so for only three or four years. Franklin remembered Lake Arthur principal Bob Dolan standing on the wharf scolding Franklin's father, telling him he'd better send his children to school.

Franklin also talked about the once large shell mound located at the southeastern edge of Grand Lake at Chênière du Fond. According to Franklin, the mound was hundreds if not thousands of years old. It was probably six hundred yards long and perhaps fifteen to twenty feet high, and it was in the shape of a huge alligator. Franklin Price said that when his oldest brother, Warren, was a kid, he would play on the shell mound. Unfortunately, sometime in the 1930s, the W.T. Burton Company dug Martin Canal to the shell mound, allowing it access to load the shell onto barges. An injunction stalled the demolition of the shell mound for perhaps two years. The Burton Company must have won the legal battle, because the mound no long exists. It vanished, much like what is happening to the fur industry. Franklin has seen the industry go from the best of times to the worst of times. Today, it is a shadow of its former self, he says. He left the fur trade and fishing industry in the 1970s to become a commercial shrimper. He purchased a fifty-foot shrimp trawler and named it *Captain*

Price. It was built in 1951 by a shipbuilder from Montegut, Louisiana, south of Houma in Terrebonne Parish. Franklin kept the trawler for forty years until the numerous government restrictions on commercial shrimpers made it unfeasible for him to continue his livelihood. He and his lovely wife, the former Norma Conner, are now retired and continue to live at their lakeside home in Lake Arthur. They keep busy by visiting family and friends and spending time at their camp at Chênière du Fond.

Bibliography

Abbeville Meridional. "Historical Sketches of Vermilion Parish #I." October 28, 1905.
———. "Historical Sketches of Vermilion Parish #II." November 4, 1905.
———. "Historical Sketches of Vermilion Parish #III. November 18, 1905.
———. "Historical Sketches of Vermilion Parish #IV." December 23, 1905.
———. "Recollection of the Great Civil War part 1 of 3." July 3, 1926.
———. "Recollection of the Great Civil War part 2 of 3." August 21, 1926.
———. "Recollection of the Great Civil War part 3 of 3." September 25, 1926.
Ancelet, Barry. Personal communication with the author. March 2010, Lafayette, LA.
Arceneaux, Maureen G. "Rail Comes to Acadiana: One Man's Plaintive Response." *Attakapas Gazette* 24 (1989): 169–73.
Beaumont Enterprise. "Farmer at Nome Shot to Death in Cottonfield." August 31, 1926.
———. "Two Sons of Slain Man are Arrested." September 1, 1926.
———. "Youths Sent to Liberty." September 2, 1896.
Beaumont Journal. "Liberty Farmer Is Killed in Gun Fight with Deputy." August 31, 1926.
———. "Two Sons Arrested at Grave of Man Shot by Officer." September 1, 1926.
Brassieur, C. Ray. Personal communication with the author. June 2012, Rayne, LA.
Calhoun, Robert Dabney. "The Origin and Early Development of County-Parish Government in Louisiana (1805–1845)." *Louisiana Historical Quarterly* 18, no. 1 (January 1935): 56–160.
Castille, Eric. Personal communication with the author. August 2012, Lafayette, LA.
Crescent of New Orleans. "Overflow of Last Island: Terrible Loss of Life." August 14, 1856.
Crowley Signal. "Accused Girl Threatened Through Jail Window with the Fate of Man She Loved." November 22, 1913.

———. "The Act of a Fiend." November 24, 1894.

———. "Appeal Taken to Supreme Court." November 20, 1913

———. "Bond for Murff Girl Asked in High Court." October 7, 1914.

———. "Dora Murff and Father Taken to Opelousas." August 15, 1914.

———. "Dora Murff Case in Supreme Court." January 24, 1914.

———. "Dora Murff May Be Brought Back." August 8, 1914.

———. "Food Not Eaten by Dora Murff in 3 Days." August 1, 1914.

———. "In Supreme Court." March 28, 1914.

———. "Jury Convicts." December 6, 1913.

———. "Last Hope of Dora Murff Lies in United States Supreme Court." July 4, 1914.

———. "Plea of Former Jeopardy in Duvall Murder Case." November 29, 1913.

———. "A Prisoner's Story: He Tells of the Several Plans of Thibodeaux to Escape." February 22, 1896.

———. "Supreme Court of Louisiana Grants Writ of Error in Case of Dora Murff and James Duvall." July 11, 1914.

———. "Thibodeaux's Escape: The Train Wrecker Tells How He Got Out of Jail." February 15, 1896.

———. "Walter J. Donlon Sr." March 19, 1927.

———. "Woods and LeDoux Captured at Basil by Sheriff Fontenot and Deputies." July 18, 1914.

Daigle, Brenda Briggs. Personal communication with the author. March 29, 2014, Rayne, LA.

Daigle, Carlos. Personal communication with the author. March 29, 2014, Rayne, LA.

Daigle, Patrick. Personal communication with the author. March 2012, Pointe Noir, LA.

Daigle, Paul. Personal communication with the author. June 2017, Pointe Noir, LA.

Daigle, Pierre V. *Tears, Love and Laughter: The Story of the Cajuns and Their Music.* San Francisco: Swallow Publications, 1987.

Daigle, Selise. Personal communication with the author. January 2012, Pointe Noir, LA.

Delta of New Orleans. "Red River Not Bluffed." August 1, 1854.

DeWitt, Mark F. Personal communication with the author. February 2011, Rayne, LA.

Dismukes, J. Philip. *The Center: A History of the Development of Lafayette, Louisiana.* Lafayette: City of Lafayette, 1972.

Dixon, Bill. *Last Days of Last Island.* Lafayette: University of Louisiana at Lafayette Press, 2009.

Du Bois Review. "The Opelousas Railroad Convention." July 4, 1851.

Duplechain, Raphael. Telephone conversation with the author. May 2012.

Edmonds, David C. *Yankee Autumn in Acadiana: A Narrative of the Great Texas Overland Expedition through Southwestern Louisiana.* Lafayette: University of Louisiana at Lafayette Press, 2005.

Fama, Anthony P. *Plaquemine: A Long, Long Time Ago.* Plaquemines, LA: Anthony Fama, 2004.

Fontenot, John Sherrill. "The Creation of Evangeline Parish." *Ville Platte Gazette*, September 18, 1958.

Franklin Journal. "The Last Island Calamity." August 11, 1856.

Gisclair, Beverly. Telephone conversation with the author. December 4, 2018.

Guess, Debbie Holeman. Personal communication with the author. February 23, 2013, Patterson, LA.

―――. Personal communication with the author. December 5, 2018, Patterson, LA.

Guilbeau, Albert J. Personal communication with the author. November 2010, Lafayette, LA.

Guilbeau, Eva Dell. Personal communication with the author. November 2010, Lafayette, LA.

Hawkins, M.E., and C.J. Jirik. *Salt Domes in Texas, Louisiana, Mississippi, Alabama and Offshore Tidelands: A Survey*. Bureau of Mines Information Circular 8313, 1966.

Hebert, Kelly. Personal communication with the author. March 2016, Church Pointe, LA.

Iberville South. "Last Island Submerged: Awful Calamity! 116 Lives Lost!!" August 14, 1856.

Klingberg, Frank W. *The Southern Claims Commission*. Berkeley: University of California Press, 1955.

Kupfer, Donald H. *Geology and History of the Belle Isle Salt Mine: The Southernmost Five Islands Salt Dome, St. Mary Parish, Louisiana*. Geological Pamphlet 11. Baton Rouge: Louisiana Geological Survey, 1998.

Labbé, Ronald, and Jonathan Lurie. *The Slaughterhouse Cases: Regulation, Reconstruction, and the Fourteenth Amendment*. Lawrence: University Press of Kansas, 2003.

Lafayette Advertiser. "Ambroise Mouton." December 20, 1902.

―――. Ax Woman Found Guilty of Murder." October 26, 1912.

―――. "Fireman Patin's Funeral Is Largely Attended." October 17, 1914.

―――. "Negress Confesses: Clementine Bernabet Gives Detailed Account of Axe Murders in Rayne, Crowley, and Lafayette." April 5, 1912.

―――. "Negroes Alarmed: Attempts to Enter Houses at Night Continue. No Clues to Miscreants." February 13, 1912.

―――. "New Letter in Axe Murder Case." May 17, 1912.

Lafayette Daily Advertiser. "Lafayette and Railroad History Parallel." December 31, 1949.

Lafayette Daily World, July 29, 1982.

La Louisiane. "Playing It Forward." Summer 2011, 8.

Lamar, William "Bill." Personal communication with the author. 2012–18.

Landry, Russell. Personal communication with the author. December 28, 2012, Kaplan, LA.

LeBlanc, Albert "Buzz." Personal communication with the author. November 2018, Breaux Bridge, LA.

LeBlanc, Allen. Personal communication with the author. December 2012, Abbeville, LA.

LeBlanc, Ralph. Interview, 1987, CODOFIL and Louisiana Public Broadcasting.

Marx, Groucho. *You Bet Your Life*. NBC television show, January 18, 1951.

Monroe News-Star. "Belle Isle Fire Top State Story." December 30, 1968.

Moreaux, Joseph. Personal communication with the author. 2012–2018.

New Iberia Enterprise. "An Historical Document." March 11,1899.

New Iberia Enterprise and Independent Observer, December 6, 1913.

New Orleans Democrat. "New Orleans Fairgrounds." April 8, 1854.

New Orleans Picayune, June 6, 1963.

New Orleans Republican. "Crescent City Livestock Landing and Slaughterhouse Company." March 21, 1872.

———. "Diseased Meat." August 5, 1870.

———. "The Health of the City, Introduced by the Crescent City Livestock Landing and Slaughterhouse Monopoly." July 10, 1870.

New Orleans Times Picayune. "Poor Evangeline Again a Victim." December 1, 1923.

Philippine Sea shipboard newsletter. "Pilot Recovering." February 9, 1947, 2.

Price, Franklin. Personal communication with the author. June 2015, Lake Arthur, LA.

———. Personal communication with the author. September 2018, Gueydan, LA.

Prichard, Walter. "Southern Louisiana and Southern Alabama in 1819: The Journal of James Leander Cathcart." *Louisiana Historical Quarterly* 28, no. 3 (1945): 735–921.

Rice Belt Journal. "Working on Axe Murders: Confession of Missouri Convict May Lead to Solving of Mysteries." May 23, 1913.

Robbins, James. "Antarctic Mayday." 1981. http://www.south-pole.com/p0000153.htm.

Sothern, James M. *Last Island.* Houma, LA: Cheri Publishing, 1980.

Southern Pacific Bulletin. "A Century of Progress in Louisiana, 1852–1952." October 1952.

St. Landry Clarion. "Compromise on Division Has Been Reached." June 4, 1910.

———. "Ville Platte Wins Parish Seat Fight." November 13, 1909.

St. Martinville Weekly Messenger, July 18, 1914.

———. "Death of Judge Edward Simon." February 14, 1914.

St. Mary and Franklin Banner-Tribune. "All 21 Trapped Miners Dead, 16 in Tunnel, 5 Under Water." March 9, 1968.

———. "Double Talk by Nora & Ella." March 20, 1968.

Thibodeaux, Wilson. Personal communication with the author. February 2010, Rayne, LA.

Voorhies, Felix. *Acadian Reminiscences: The True Story of Evangeline.* New Orleans: E.P. Rivas, 1907.

ABOUT THE AUTHOR

William, his wife, Judy, and Baby Bear their toy poodle live in Lafayette, Louisiana. Over the past twelve or so years William has written numerous articles for several newspapers and publications. This is his first book.

Visit us at
www.historypress.com
..